A BEAUTIFUL MESS
PHOTO IDEA BOOK

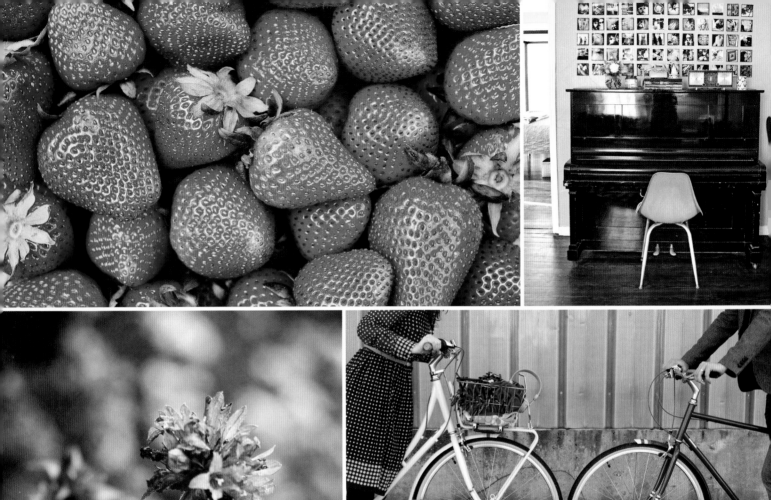

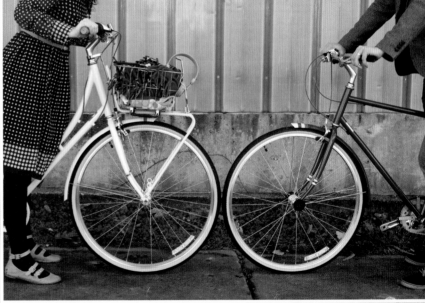

The Best-
Coffee in
town

FROM THE CREATORS OF A BEAUTIFUL MESS
elsie larson AND *emma chapman*

A BEAUTIFUL MESS PHOTO IDEA BOOK

95 INSPIRING IDEAS FOR PHOTOGRAPHING YOUR FRIENDS, YOUR WORLD, AND YOURSELF

AMPHOTO BOOKS

an imprint of the Crown Publishing Group / New York

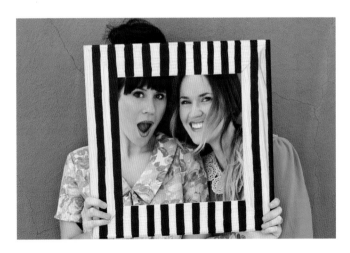

Published in the United States by Amphoto Books, an imprint
of the Crown Publishing Group, a division of Random House,
Inc., New York.
www.crownpublishing.com
www.amphotobooks.com

AMPHOTO BOOKS and the Amphoto Books logo are
trademarks of Random House, Inc.

Some of the photos included herein were previously
published on www.abeautifulmess.com

Library of Congress Cataloging-in-Publication Data
Larson, Elsie.
A beautiful mess photo idea book / by Elsie Larson and
Emma Chapman.—First edition.
 pages cm
1. Portrait photography. 2. Self-portraits. I. Chapman,
Emma. II. Title.
TR575.L35 2013
771'.44—dc23

 2012023524

ISBN 978-0-7704-3403-8 (trade pbk.)
ISBN 978-0-7704-3404-5 (e-book)

Printed in China
Design by Jenny Kraemer

10 9 8 7 6 5 4 3 2 1

First Edition

This book is dedicated to our grandparents,
Norman and Corina Patterson.
Thank you for capturing your life together in photos.
It's beautiful.

ACKNOWLEDGMENTS

We wish to thank the following people for their generous
support in producing this book: our creative and supportive
family, Jeremy Larson, Kinsey Mhire, Sarah Rhodes, Janae
Hardy, Katie Shelton, Lindsey Edgecombe, Julie Mazur, and
all of the wonderful and patient folks at Amphoto Books
and the Crown Publishing Group.

CONTENTS

7

Challenge Yourself

8

Show Off Your Photos

Introduction

This is the part of the book where we explain that we are total pro photographers and you will be too if you read this book. The only problem is . . . well . . . we're not pro photographers. We're bloggers. For the past five years, we've been writing a blog called A Beautiful Mess, where we share our daily lives along with DIY projects, recipes, and all things homemade. We take all of the photos for our blog. This routine started out of necessity and has since become one of the aspects of blogging that we are most passionate about. Now you'll rarely see us without a camera. We may not be professional photographers, but we are in love with photographing everyday life, and that's what this book is about.

Our greatest photography influence was our grandpa, Norman (we called him Papa). We always think of our grandpa as a renaissance man. He moved to South America as a young man, where he met and fell in love with our grandmother. They started a family there and eventually moved to southern Missouri to start a cattle farm. Photography was a hobby of his throughout his adult life, and he left behind a beautiful collection of photos. He took photos of their home in South America. He took photos of their vacations together. He took lots of photos of our (very stylish) grandmother. He took photos of his children playing. Thanks to these photos, we have a very full picture of our grandparents' life together and our mother's childhood. We are so grateful for the way these images show us lives full of beautiful and interesting moments rather than only a few posed portraits.

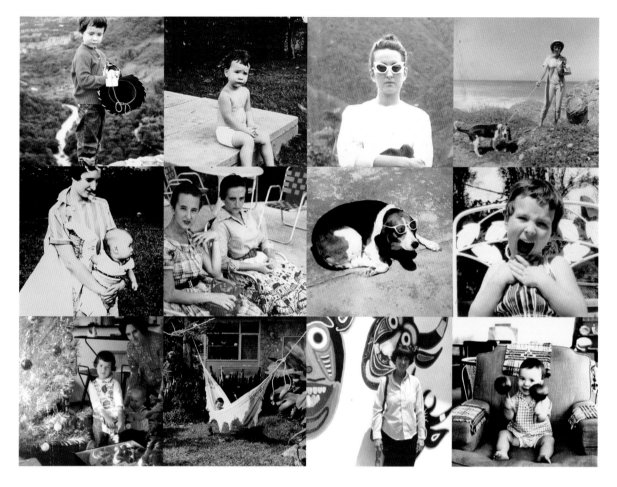

Our grandfather's photography inspires us to document our lives.

Photo technology and trends have changed a lot since our grandfather's time, but his habit of taking time to document his life is a gift that has remained with us to this day. It is often with our children and grandchildren in mind that we keep taking photos and striving to learn new and better techniques. We love the idea that they will be able to see our full lives, brimming with moments, details, and emotion. Seen this way, no photo is a waste; no event is too small or unimportant to document.

You've probably figured out by now that this book is different from other photography books. We're not going to talk about camera settings or technical work-flow. We still have tutorials, examples, challenges, and lots of ideas; it's still an informative book. But think of this as an *idea* book, to take you from whatever photography level you are at to the next one. We're going to challenge you to do things outside your comfort zone. There may be moments when we push you to take a photo you may consider a little bit silly. But we urge you to just go with it; enjoy the challenge! You may be surprised by how much you can push yourself to the next level. Our hope is that in the process, we'll inspire you to capture your real life, and that you will have tons and tons of beautiful photos that you wouldn't have taken otherwise.

So what's the best way to use this book? We suggest reading through the entire book first. Maybe use

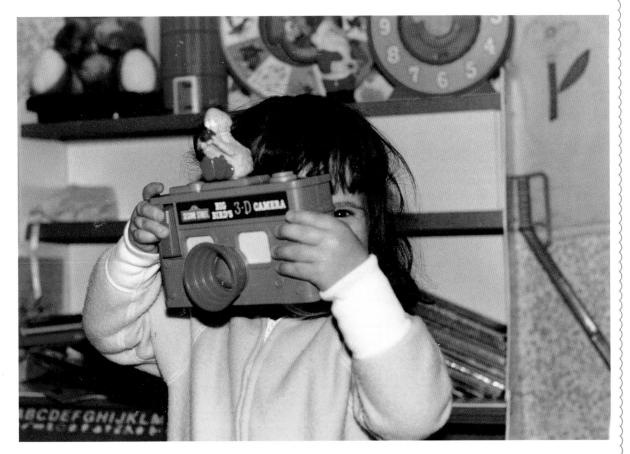

Elsie has been a photo enthusiast her whole life. Her very first photo was of her Barbie collection.

Post-its or bookmarks to keep track of the sections that inspire or excite you the most. Try all the challenges; don't be shy! Don't be too worried about making mistakes or "doing it right." Find what works for you. Try to top your personal best photo. Push yourself to try new methods for displaying and organizing photos in your home or to gift to family members. Get into it! *We're excited for you.*

xo Elsie and Emma

P.S. We apologize for all of the exclamation marks in this book. We're just excited!!!

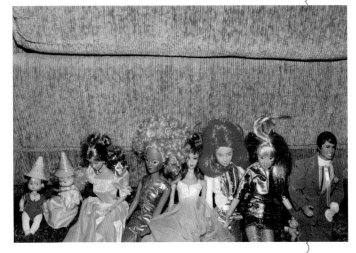

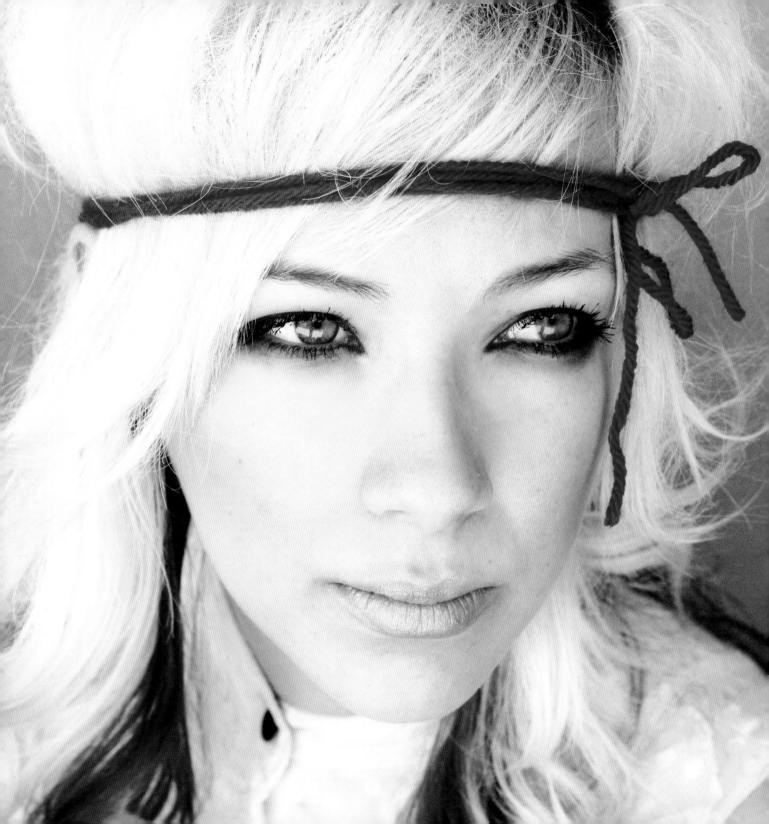

Capture Your Favorite People

Taking pictures of our friends and family is one of our favorite things to do! We spent a lot of time in our teen years taking pictures of each other and getting friends together to do special shoots. Sometimes just the act of getting together for a planned photo shoot, such as engagement pictures or a family portrait session, becomes its own memorable event. Whether you set up a special, planned shoot or simply take the time to snap a few pictures of your friends while you are out shopping, this chapter is all about getting great pictures of the important people in your life.

PHOTOGRAPH FACES

f you were using pictures to write the story of someone's life, his or her face would be chapter one. Capturing someone's best facial feature or a special expression often makes the most interesting images. Here are our top five tips for photographing faces.

✳ **TRY DIFFERENT ANGLES.** Looking straight at the camera can be great, but don't be afraid to try different angles. Have your subject look to the side or down for a few shots. This can help with people who are camera shy, too. Ask your subjects to try a few different angles to help them loosen up in front of the camera.

Here's an example of using a prop to highlight a detail: the subject's beautiful eyes.

✳ **TRY DIFFERENT CROPS.** Try super close-up crops to highlight someone's eyes or smile, as well as full-body shots with a lot of negative space to emphasize a pose or the environment.

✳ **CAPTURE THE IN-BETWEEN MOMENTS.** Sometimes when you are taking portraits—especially of kids and couples—there will be moments in between the smiling pictures when someone laughs or makes an expression that communicates so much. These unintentional moments can make the best photos because they are genuine and unique.

✳ **HIGHLIGHT YOUR SUBJECT'S BEST FEATURES.** Emphasize your subject's beautiful or unique features, such as blue eyes or a great smile, by focusing on them and putting them front and center. When you are behind the camera, you have the power to highlight these magical details!

✳ **USE A SIMPLE PROP.** Props add variety and can help your subject feel more at ease. We especially love using props from our environment, such as a leaf, a flower, a coffee cup, or anything else that happens to be on hand.

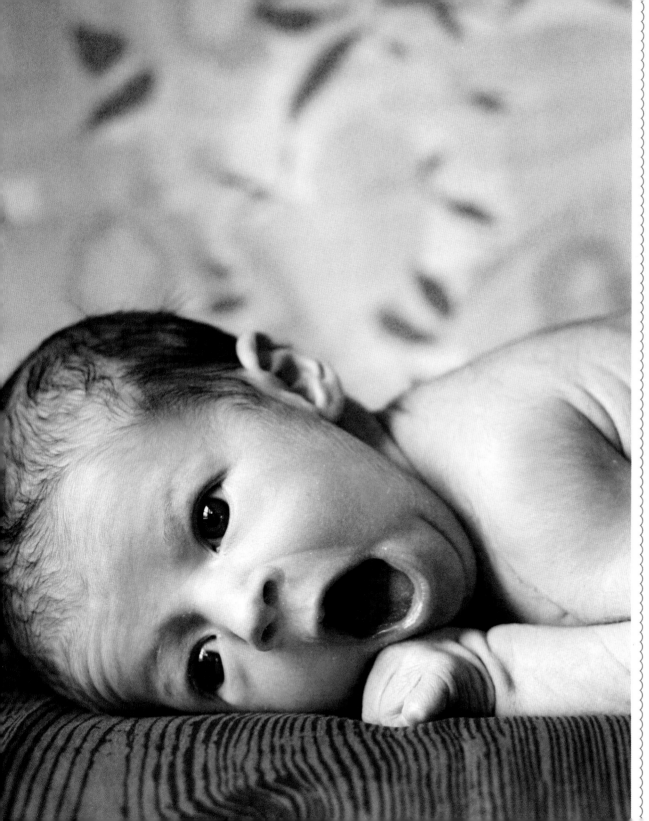

We love this
yawn from
our newborn
niece so much
more than her
traditional
portraits.

TAKE STORYTELLING PORTRAITS

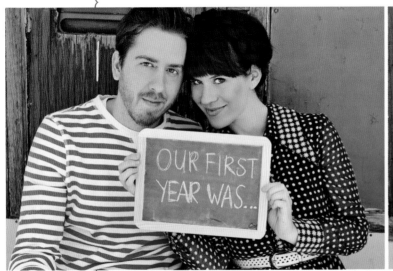
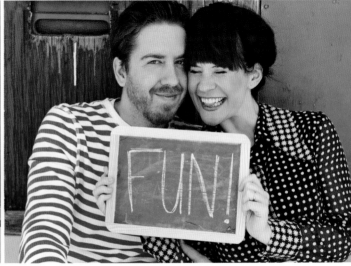

This is a great way to use pictures to communicate an idea. Create a sequence of pictures that tell a story through homemade signs, posters, or other small props. This idea is commonly used for save-the-date pictures, when a couple takes a series of photos to share the date of their upcoming wedding. It takes a little bit of planning and preparation, but is a fun way to share any message or story!

Elsie and Jeremy created these storytelling portraits to include in their wedding thank-you cards. They added a little photo message to each one, thanking everyone for making their first year of marriage so special.

good memories!

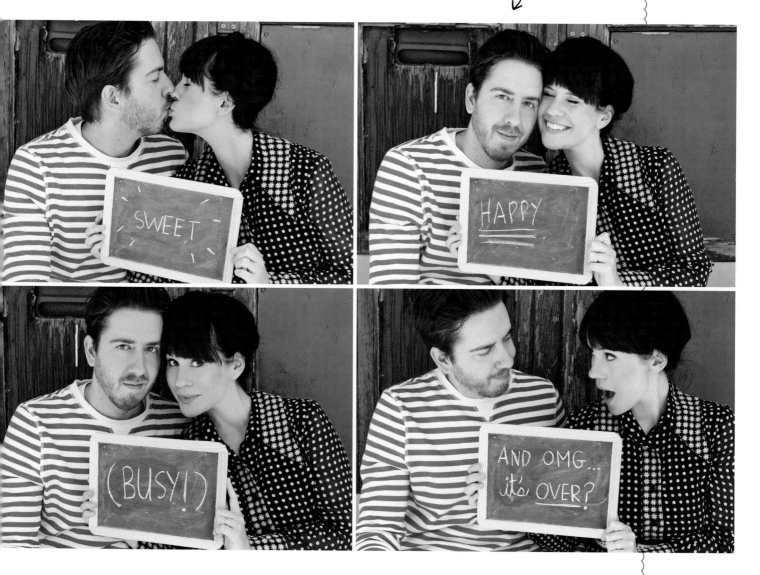

CAPTURE GENUINE EMOTION

These are the photos that will make your albums feel the most alive and human. Don't feel pressure to manufacture emotion from your subjects. Just keep your camera close, as genuine emotion happens all around us every day.

Don't forget to capture the candid moments during a shoot; they tend to be the most real. If you are photographing a group, let people talk or giggle if that's the mood of the room. Instead of trying to get the perfect "everybody face the camera and smile" picture, take a moment to photograph what is happening *now*. It's good to give friends or family members prompts and ideas while you are taking pictures; most people prefer being told how to pose or where to look. But if someone does something organically, be sure to snap a picture.

Life is full of a wide range of emotions—and your photos can be, too! We absolutely cherish an image of our little niece crying. She was a newborn at the time and cried during most of her newborn photo shoot. It would be easy to think the shoot was ruined— but that's just not true. Not every season of life is all smiles and giggles, and that's okay! We believe that every season of life is worth remembering. Don't shy away from capturing whatever genuine emotion is happening. It's all beautiful!

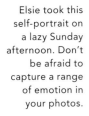

Elsie took this self-portrait on a lazy Sunday afternoon. Don't be afraid to capture a range of emotion in your photos.

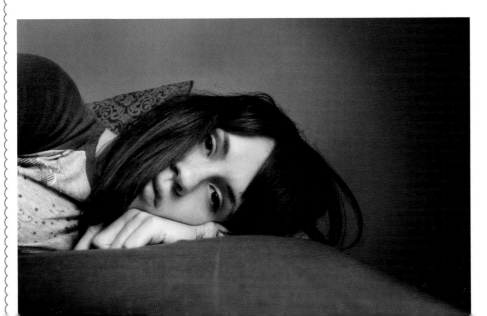

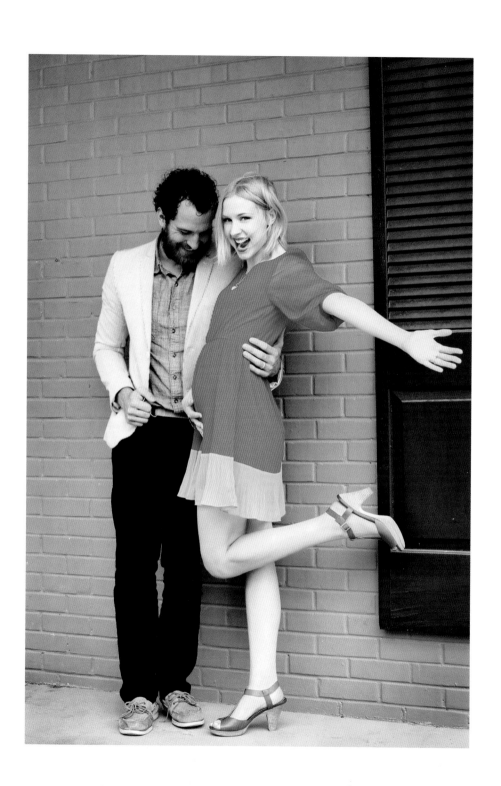

Here are
our lovely
friends Darren
and Stacy,
hamming it up
between baby
announcement
pictures.

GET ADORABLE COUPLE PHOTOS

Every couple, whether newly engaged or celebrating their fiftieth year of marriage, has their own unique story and dynamic. Find creative ways to capture their story. Try taking traditional portraits but with a twist. For example, you might try playing with different color combinations. Have the couple wear complementary colors and choose a background that suits those colors. Let the couple look at the camera, at each other, or off to the side—variety is fun! Try finding a creative way to let the couple's personality and life together shine through your picture.

Remember to include some close-up and intimate pictures. These could be of just the couple's hands or feet, or a sweet moment of them kissing. Every couple has their own level of comfort when being photographed, so choose close-up pictures that will put them at ease.

Details are another way to show a couple's unique life together. We love the image of Elsie and Jeremy's rain boots, hers plum and his green. Although you may not think of this as a "couple portrait," it does tell part of their story. Have fun getting creative and taking pictures that show off a couple's life!

Close-up images can emphasize precious moments between two people.

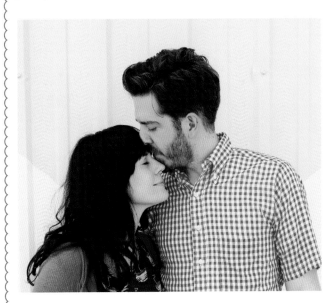

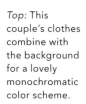

Top: This couple's clothes combine with the background for a lovely monochromatic color scheme.

Bottom: You can never have too many detail shots!

TAKE CUTE PHOTOS WITH YOUR FRIENDS

Many of us remember to bring cameras to family get-togethers or to get pretty pictures when a friend gets pregnant or engaged. But what about all the laid-back events, such as a friend's backyard barbecue or a girls' craft night? Some of our favorite memories with friends have happened when we were just hanging out. Don't be afraid to capture those moments, too. You may get labeled the friend who always brings her camera. But hey, is that really so bad? Here are three tips for getting great group photos with your friends.

✳ **USE A TRIPOD AND SELF-TIMER.** This way, you can get everybody in the shot. For more about tripods and self-timers, see page 138.

✳ **TRY A RANGE OF EMOTIONS AND POSES.** Don't get stuck on one look. And don't be afraid to get silly!

✳ **SPICE UP YOUR PHOTOS WITH SIMPLE PROPS.** Play around with props, such as vintage hats and glasses, a mini chalkboard, or anything you have on hand. Create as much variety as you can so you'll have lots of options to choose from when the shoot is over.

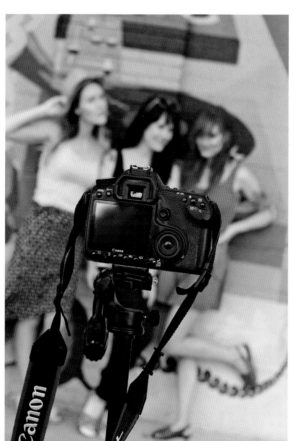

← *a tripod lets you get in the photo, too*

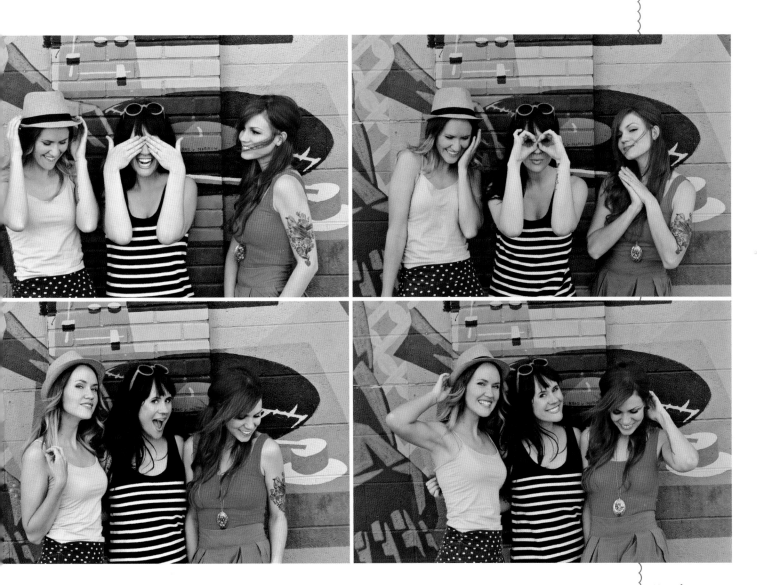

Have fun
snapping
photos with
your friends!

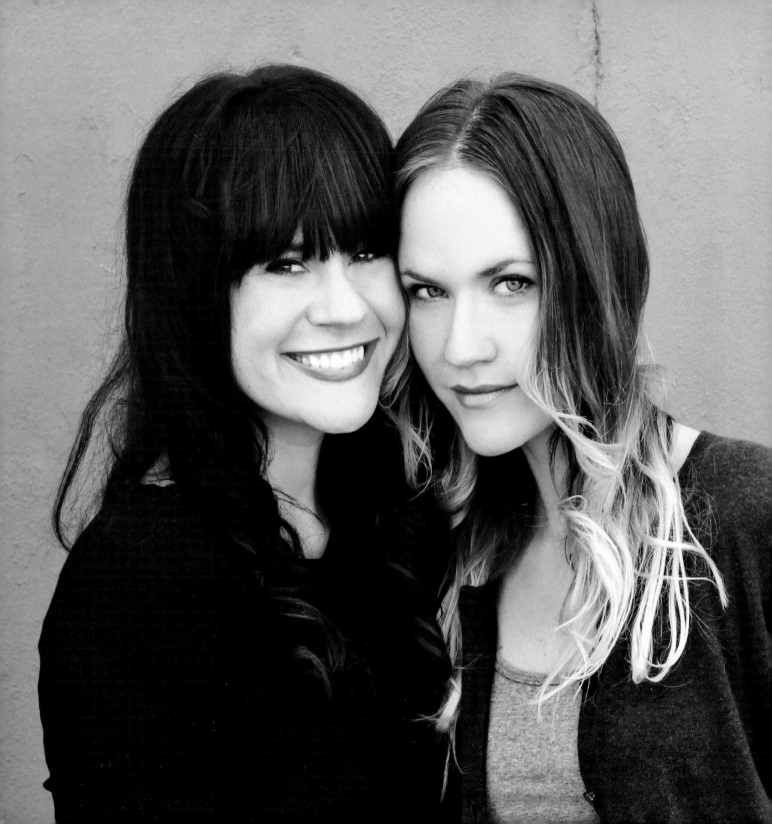

try framing your faces off-center to include a lot of negative space, especially when your background has great color or texture

GET A GREAT FAMILY PHOTO

Great family photos are something you'll cherish forever. There are as many different kinds of families as there are ways to capture them in photos. Don't be afraid to think outside the box and get photos that mean something to you. Here are our favorite tips and tricks.

✳ **GIVE THE TRADITIONAL FAMILY PORTRAIT A UNIQUE TWIST.** Try posing your family in front of a pretty backdrop: a brightly colored wall, a natural wood background, or even in your home. Show off the family's vibe through clothing choices, props, and expressions.

✳ **ISOLATE ONE MEMBER OF THE FAMILY IN HIS OR HER ELEMENT.** Family portraits can be as much about the experience as the photos that result. For example, sometimes it can be difficult to get children to hold still and smile for traditional family portraits. Instead, let them play and snap those moments, too.

✳ **CHOOSE A BACKGROUND BASED ON THE OUT-FIT, INSTEAD OF THE OTHER WAY AROUND.** We all look and feel our best in our favorite clothes. Don't try to force a color scheme onto your family portrait session. Instead, try to find a background color that works with whatever your subjects are wearing.

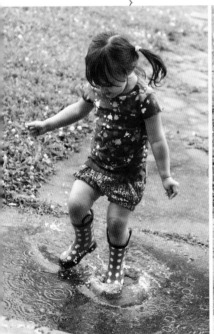
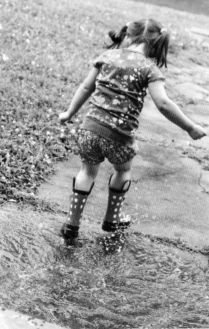

Here's Elsie's niece, Bella, playing in a rain puddle. Bella's parents absolutely adore these photos; it doesn't matter that she wasn't posing for a picture!

Left: This dark background, combined with Jeremy's dark shirt and little Bella's dark hair, creates nice contrast with their fair skin.

Below: Try to capture family members interacting, rather than just posing.

window light! →

PHOTOGRAPH YOUR PET

Dolly has a *lot* of energy—these pictures show off her personality!

We love all kinds of animals. Over the years, we've had pet hamsters, birds, cats, lizards, a bunny, and many dogs (our family is especially fond of dogs!). It can be challenging to get good photos of animals, so here are four tips for photographing your pet, demonstrated by Elsie's dogs, Dolly and Suki.

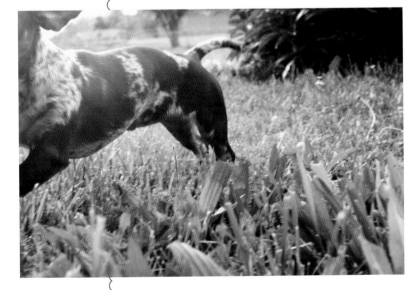

Opposite: Give yourself the freedom to take a lot of photos—and then use the very best.

✳ **CAPTURE YOUR PETS IN THEIR NATURAL STATE.** You may want to get the perfect portrait of your pet sitting (or lying or hanging) and looking at the camera, but sometimes that just doesn't happen. Elsie's dog, Dolly, is the perfect example. She is extremely energetic at this age in her little puppy life. Pictures of her running out of frame and jumping at the camera show off her cute personality.

✳ **USE TREATS AS BRIBES.** This is a sneaky way to get your pet to sit still for a photo. Hold the treat just above the camera lens and then snap away. The result is a win-win: cute photos for you, and a little treat for your pet!

✳ **GIVE YOUR PET A COSTUME OR SIMPLE ACCESSORY.** Try putting your pet in hats or bandanas to add a little color and interest to your photos— just make sure to use garments and materials that are pet safe.

✳ **TAKE A LOT OF PICTURES.** Thanks to digital cameras, it's easier than ever to snap away. And when you are photographing pets, it's especially useful to take a lot of extra pictures. Your subject may move slightly (or a lot!) at the last second, blurring your picture. So take a lot of photos and know that you will end up using only the very best.

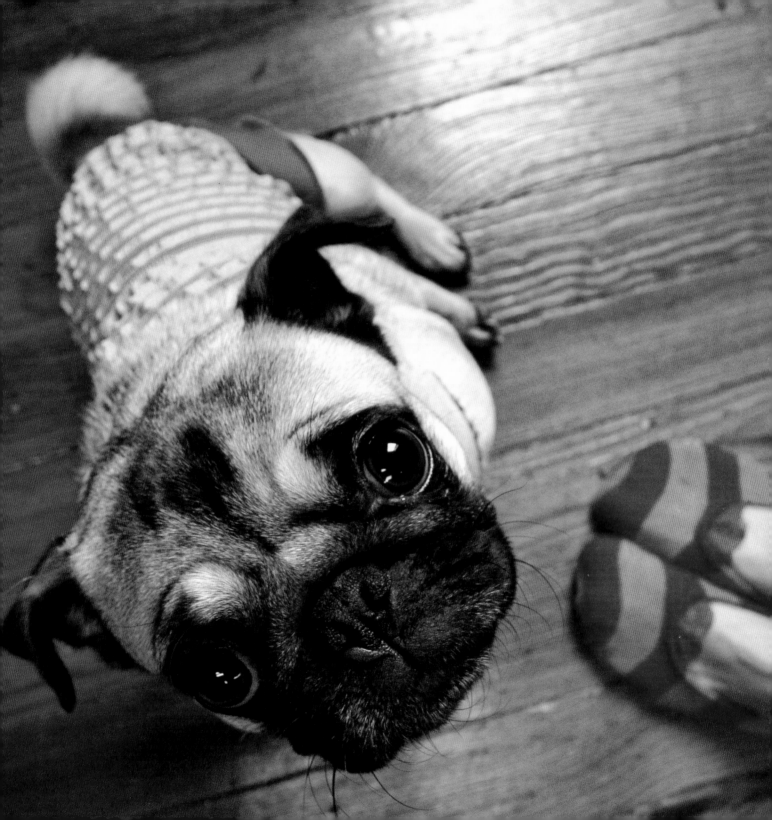

CAPTURE UNIQUE PERSONAL DETAILS

All of the people in your life have special details that make them unique: interests, likes and dislikes, shared stories with you, features they are proud of. These are the things that remind you the most of each person—why not capture them in photos? For example, our mother has always been the biggest champion of creativity in our lives, so we love photographing her art studio. Having a photo of her messy paintbrushes means something to us and makes the picture special.

what details make your life special?

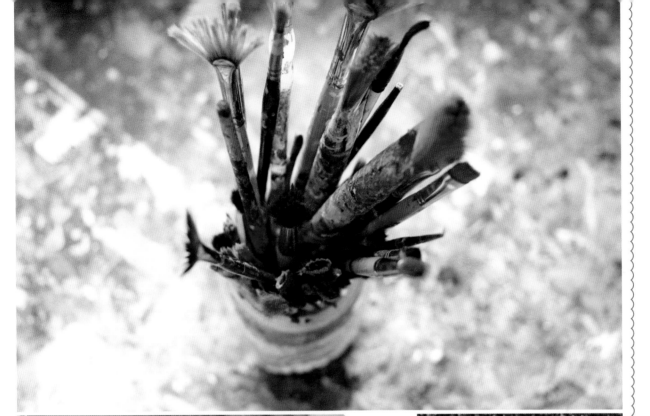

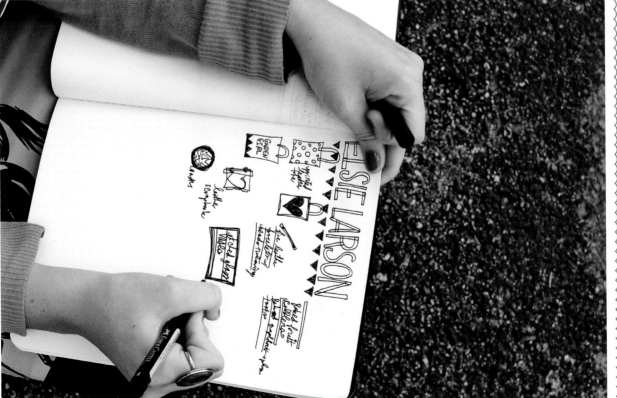

Unique
personal details
could include
your friend's
favorite food,
physical feature,
or hobby.

GET THE BEST CELL PHONE (OR POINT-AND-SHOOT CAMERA) PHOTOS

Sometimes we just don't have our dSLR camera ready to go. Maybe we left it at home, maybe we brought it but forgot to put a memory card in it (we've done this one a bunch of times!), or maybe the battery just died. Whatever the case, if you have a cell phone (we love using our iPhone cameras) or a small point-and-shoot camera with you, you can still get beautiful photos of friends and family. Here are three tips for getting the very best cell phone pictures.

✳ **CAPTURE AS MUCH LIGHT AS YOU CAN.** Light is essential for good photos, especially if you are using a lower-grade camera. Low-light photos can turn out blurry or grainy (not to mention, um, dark). Move or ask your subjects to move toward light sources whenever possible.

✳ **GET CLOSE.** Some of the very best cell phone photos focus on one detail, close up. Just be careful not to zoom in so close that you lose detail or can't tell what the subject is. Use your cropping skills to fill your frame and find the perfect angle.

✳ **EXPERIMENT WITH APPS.** Try to find effects that are similar to how you would edit your photos in Photoshop or other editing software. Photo apps can take your camera photos to a whole new level. Play around with a few and see what you like best. Some of our current favorites include Instagram, VSCO Cam, and Picture Show.

Cell phones
and inexpensive
point-and-shoot
cameras are
great because
you always have
them on hand.

2

Add Backdrops and Props

Details are what take a photo from good to great. It is absolutely vital to think about the whole picture when you are exploring with your camera. Let's take some time to think about backdrops and props. We are going to show examples and talk about finding the best natural backdrops and props, along with how to create your own using inexpensive and easy-to-find materials. You don't need a fancy studio or a lot of money to take your photos to the next level. Homemade backdrops and props can be the perfect solution!

FIND GREAT BACKGROUNDS FOR OUTDOOR PORTRAITS

We have taken photos all over our little hometown! We are constantly on the lookout for new and different background options. The first thing you need to keep in mind when scouting outdoor locations is lighting. We'll talk more about lighting in Chapter 3, but for now the important thing to know is that if it's a sunny day and you're taking a photo outside, you always want to look for shade. So if you find a pretty wall that you want to use as a background but it's in direct sunlight, what can you do? Walk around the building and see if any sections of the wall are in shade. If not, make a mental note and come back to the same wall later, when the sun is lower in the sky, or on a cloudy day. If you're feeling adventurous, you can try a few photos in bright sunlight, but it's best to find shade if at all possible.

When you're looking for backgrounds, pay attention to color, patterns, natural tones, and textures. You might spy the coolest backdrop in bright yellow, but if your subject is already wearing yellow, this may not be the best choice for your photo. The background should complement, not compete with, the subject. You want a backdrop that makes your photos pop but doesn't distract from the focal point. Textures and patterns can add interest to an otherwise boring picture, but be careful of overloading your photos with too many patterns.

Finally, keep in mind that you don't necessarily need a huge backdrop for every photo. Maybe you want to snap a few face shots of your cousin for her senior portraits. Even a small patch of pretty wall among a huge tangle of urban mess can be a great backdrop; just use your cropping skills and take care to center your subject exactly where you want her to be.

always keep an eye out! ↘

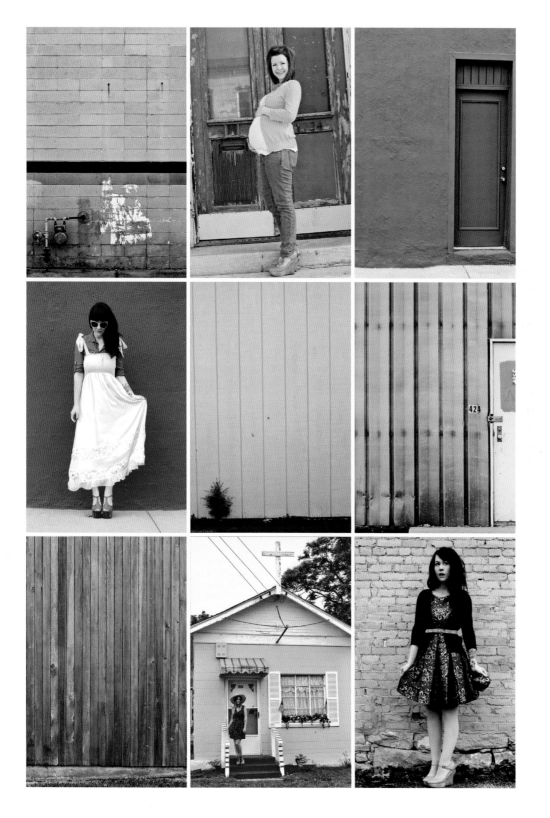

Look for a
variety of colors
and textures
when scouting
outdoor
backgrounds.

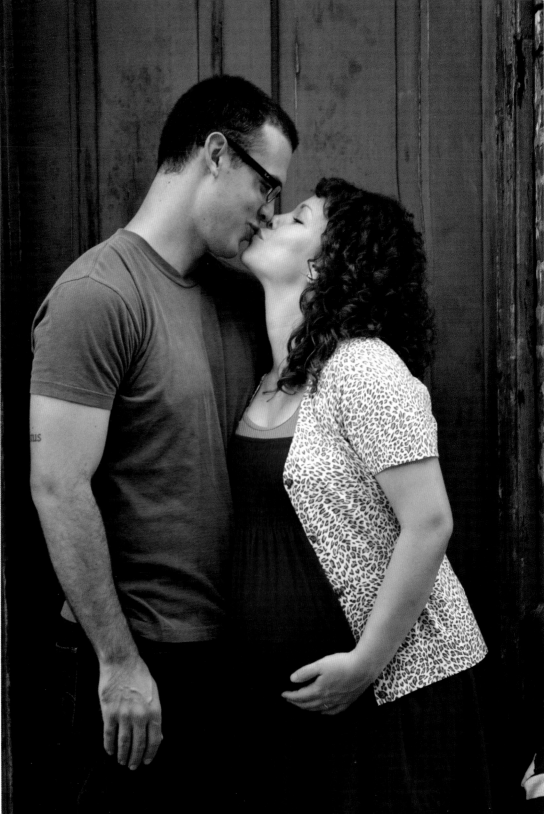

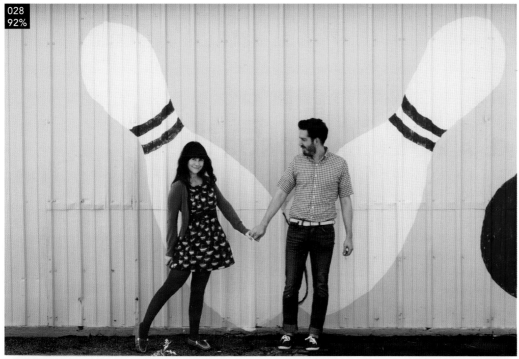

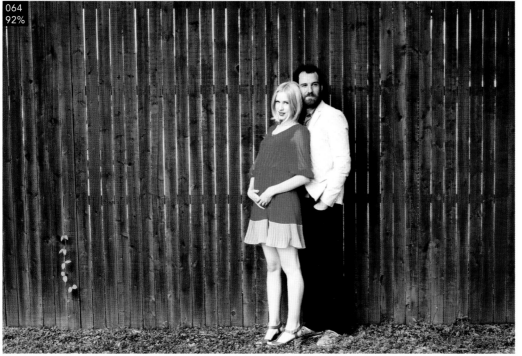

If it's a bright sunny day, interesting walls like these not only create great backgrounds, but can also keep your subjects in the shade, which is always more flattering than harsh sun.

MAKE A PAPER BACKDROP

So what happens when it's too cold or rainy to take pictures outdoors? Don't worry, because you still have all sorts of options! You can create an indoor backdrop out of all sorts of materials. Paper, for example, is an ideal material for photo backdrops: it's lightweight, inexpensive, disposable, and it comes in a variety of textures and colors. Try making a backdrop from vintage wallpaper, large panels of brown kraft paper, or old newspapers. Use whatever you have on hand or seek out pretty papers at your local craft or paper store.

If your papers are inexpensive or you don't mind throwing them away after the photo shoot, why not draw on them? Create thought bubbles to show what your subjects are "thinking," or draw a fun design to go with the theme or feel of your shoot, such as a treasure map for a kid's party. With a disposable paper backdrop, the only limit is your own creativity.

duct tape + vintage wallpaper ↬

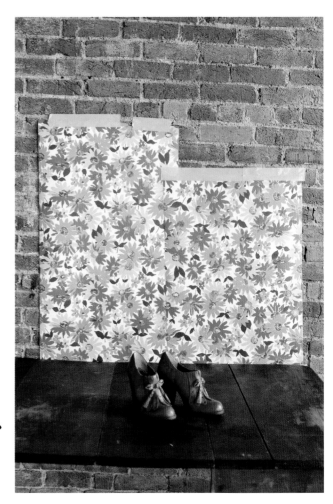

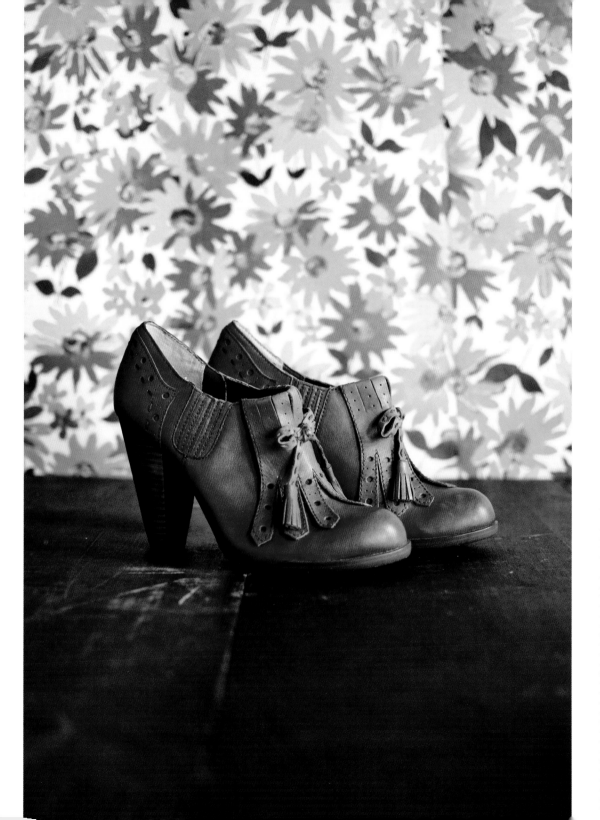

Here we
created a
simple backdrop
using vintage
wallpaper and
tape. It's that
simple, folks!

MAKE A CHALKBOARD BACKDROP

This idea requires investing a little time and money, but you will be creating a backdrop that you can use over and over again in a variety of ways.

To make the backdrop, all you need is a large, thin piece of wood (this can be any size, but since you'll probably want to move the board to different locations, it should be lightweight and fit in your vehicle), chalkboard paint (available at most home improvement stores), paintbrushes, and chalk. Cover your work area in newspaper and lay out your board. Paint a thick layer of chalkboard paint onto your board. You will probably need a few coats; we used three. Consult your paint can for drying times. Be sure to allow each coat to dry in between, and do not use your board until it is fully dry.

Emma painted this chalkboard backdrop in one afternoon. Easy!

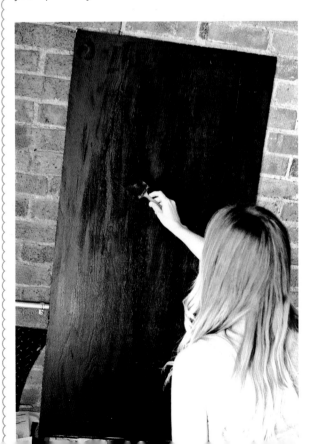

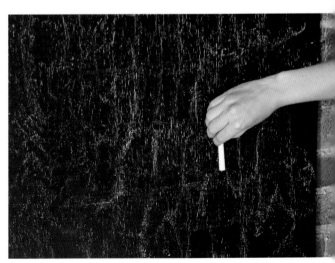

Before using it for the first time, be sure to "slate" the surface of your new chalkboard.

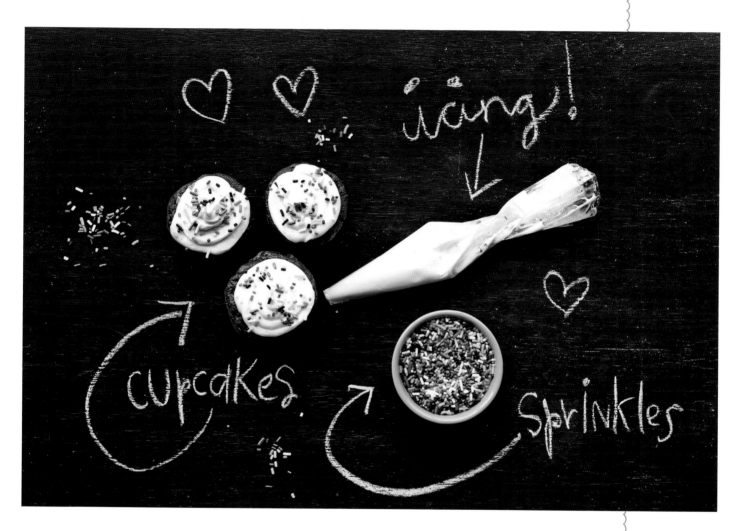

Before you use your chalkboard for the first time, it is vital that you "slate" the surface. To do this, use the side of a piece of chalk to gently rub the entire surface of the chalkboard, then gently wipe off the chalk. Now you're ready to begin. If you ever have trouble erasing messages on your board, use a little water or glass cleaner to remove excess chalk.

Now it's time to get creative. Just like drawing on a paper backdrop, chalkboard backdrops offer nearly endless options. One of our favorites is to create labels for dessert table setups for parties. It looks cute, alerts guests to the selection of desserts being served, and translates into memorable photos for your party.

Use your backdrop to add to the look of your next party. What a delicious photo moment!

MAKE A FABRIC BACKDROP

For this type of backdrop, you'll need a piece of fabric large enough to cover the area behind whatever picture you want to take. If you are doing a food photo shoot, you only need enough fabric to cover the negative space behind your food. If you plan to photograph a large family, you will need a much larger piece.

We created our first fabric backdrops from old quilts when we were teenagers. We simply hung them over our parents' clothesline in the backyard to snap a few photos of ourselves. Back then, we didn't have any technical knowledge about photo backdrops; we were just having fun!

You can use a clothesline or just tape your fabric to a wall. If your fabric is lightweight, it will be easy to tape up. You may need to drape heavier fabrics over a chair or clothesline. Experiment and see what works with the material you plan to use.

When choosing your fabric, think outside the box. Try using found fabrics such as thin quilts or bedsheets, fabrics with retro or country-looking floral patterns, or fabrics with extreme textures, such as burlap or lace. Each option will give your photo a different feel, so choose one that matches the vibe you want in your pictures.

It may look messy, but with a little cropping (opposite), this fabric will make an excellent backdrop.

let the fabric reach the floor ↘

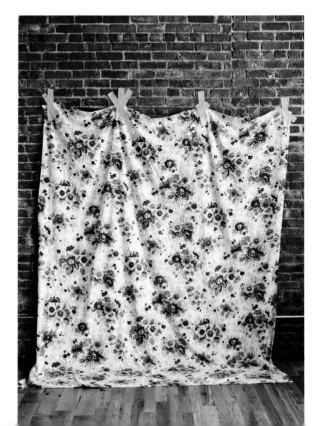

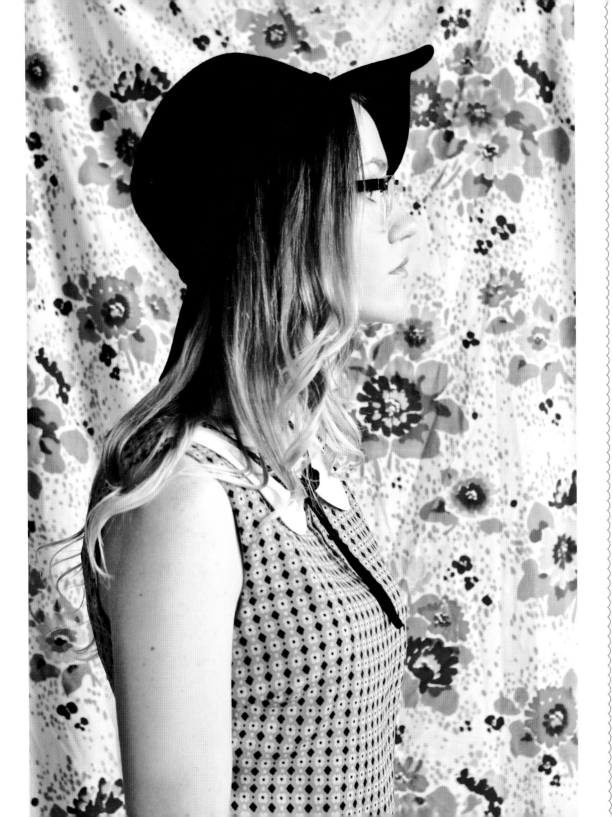

MAKE A FABRIC STRIP BACKDROP

The main problems you may encounter when creating a fabric backdrop (see page 44) are not having enough fabric or not wanting to purchase enough, as it can get expensive (most cotton fabrics are inexpensive, but other materials can be pricey). When faced with either of these, our favorite solution is to create a fabric strip backdrop.

To do this, you will need to use a clothesline as your base (you can use thin rope, sturdy yarn, or whatever else you have on hand). Cut your fabric into long strips and tie the end of each strip to the clothesline. Continue until you have covered the entire background. You can use multiple fabrics to fill out the backdrop, mixing colors, textures, or patterns.

We created this fabric strip background using different shades of mint.

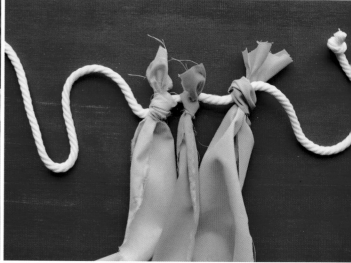

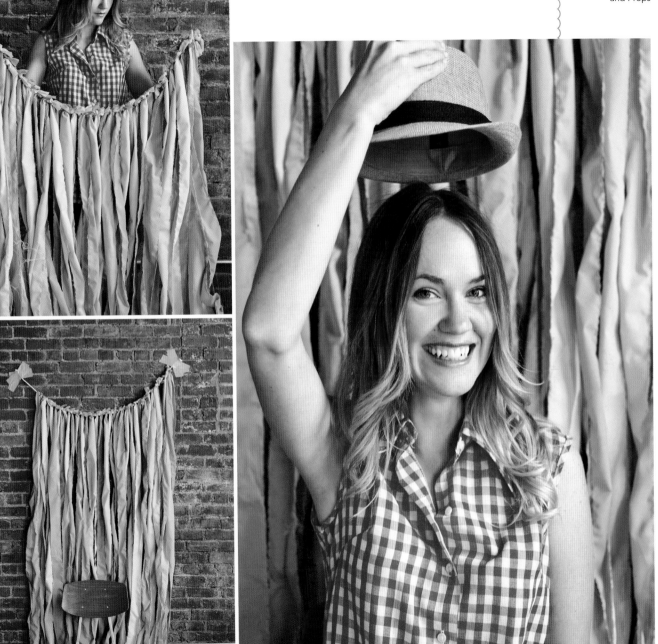

FIND PROPS AT HOME

Another way to add variety and personality to your pictures is through props. You may already have the perfect photo props right under your nose! Here are five tips for identifying and using props from your home.

✳ **KEEP IT NATURAL.** Think about activities and items that mean something to you and your family and use props tied to those things, such as books, a special collection (Elsie has a massive shoe collection!), lawn ornaments or chairs, lamps, maps or other posters, or whatever is special to you.

✳ **USE A FAMILY HEIRLOOM.** Old (vintage) items, such as quilts or old trunks, can have so much personality. Plus, using an heirloom in a photo is a great way to remember your heritage.

✳ **USE PROPS THAT REQUIRE SOME ACTION.** Having a bit of action during a photo shoot can make things feel more natural. This can be a big help when posing kiddos, too. Try snapping photos during a family game of horseshoes, or while roasting marshmallows, playing in the sprinkler, or snuggling on the couch with popcorn for movie night.

✳ **USE ARCHITECTURAL ELEMENTS IN YOUR ENVIRONMENT.** Pose with your family by a cute gate or doorway. Look for textures, such as old wooden fences or plastered walls, which can add interest to your photos.

✳ **KEEP IT SIMPLE.** Whatever you decide to use, keep it to a minimum. You don't want your photos to end up looking cluttered, too busy, or overproduced.

Props such
as old family
blankets add a
personal touch
to your photos.

MAKE YOUR OWN PROPS

Making your own props ahead of time allows you to control the colors and textures in your photos. Maybe you are planning a little boy's birthday party and decide to paint all the props blue because that's his favorite color. Or you could do double duty and make props that you then display around your home or office. We had so much fun creating these ABM letters just by adding yarn to premade cardboard letters. A Beautiful Mess not only is the name of our website but also perfectly describes our studio most of the time—ha! So we liked the idea of creating these initials for a photo and then displaying them in the studio afterward.

Try creating props that give your subjects ideas about how to use them, such as a silly pair of oversized glasses made from cardboard and yarn, an empty painted frame, tissue paper flowers or pom-poms, a cake (bonus: you can eat it afterward!), party hats or crowns made from pipe cleaners, or a mini chalkboard for folks to write on. Props can be as silly or pretty as you want when you're the one creating them.

We covered premade letters with yarn for a prop that does double duty as a studio display.

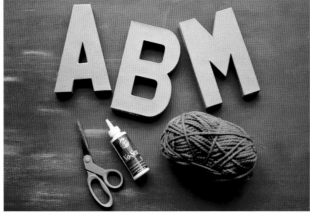

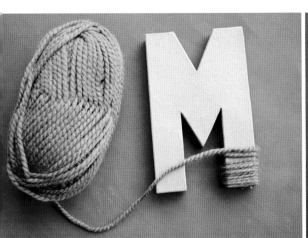
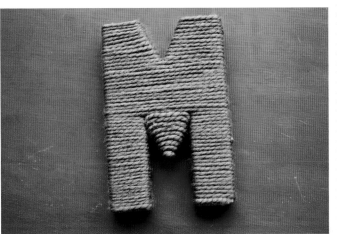

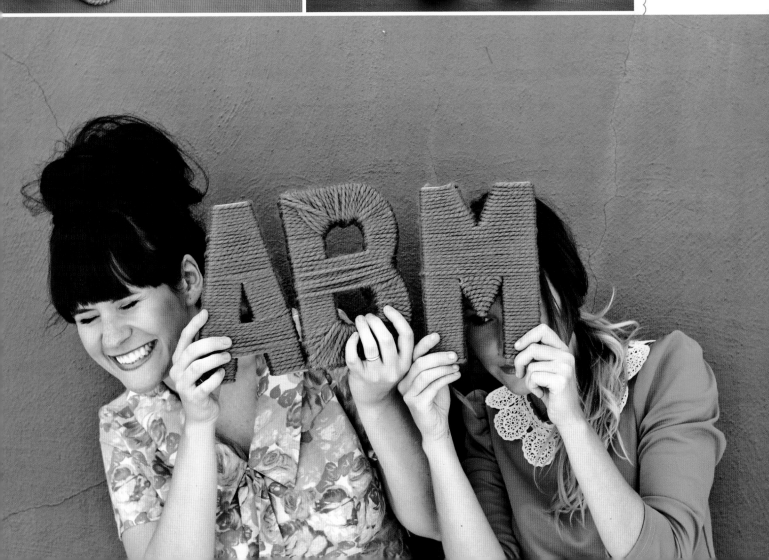

TEN IDEAS FOR CREATIVE LIFESTYLE PROPS

Look around your life this week and notice things that could add to a photo-worthy moment! It's great to include seasonal touches when you can. Here are ten ideas to get you going:

1. *Books:* a current read or vintage books that you own.
2. *Vintage artwork:* old needlepoints or paint-by-numbers.
3. *Umbrellas:* perfect for an early spring photo.
4. *Cameras:* we already know you love photography, so, like, show off your gear.
5. *Flowers or fall leaves:* whatever is growing in your neck of the woods.
6. *Instruments:* so many loved ones in our lives play music, it's hard not to highlight them.
7. *A feather crown* (or other hair accessory): get fancy!
8. *Vintage suitcases:* these can add a lovely pop of color.
9. *Bike:* you don't have to be riding—just show off your pretty wheels.
10. *Quilts, blankets, scarves:* these can make photos feel warm and cozy.

find cute props anywhere and everywhere! →

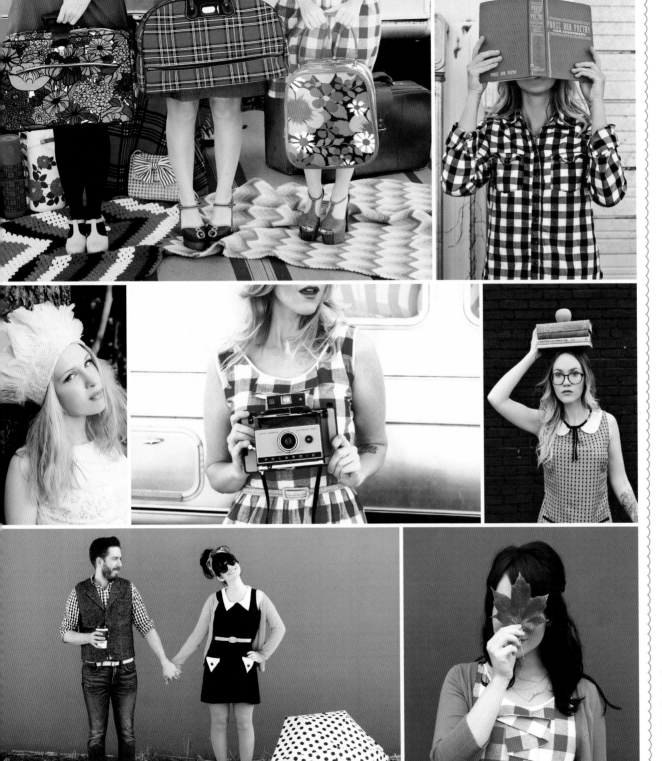

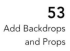

You probably have a ton of great photo props in your home right now!

3

Use Beautiful Lighting

The best photographers are those who can find and use whatever light there is. Without light we don't *see* anything in a photo. Finding and working with whatever light is available is one of the skills we are continually learning. It can be frustrating to take pictures all afternoon only to realize that it was too dark and all your photos are blurry. In this chapter, we are going to talk about how you can find and manipulate the best lighting situations for photos.

KNOW HOW TO USE
OVERCAST LIGHT VS. DIRECT SUN

You need light for pictures, it's true. But this doesn't mean you need to be in the brightest spot possible. When you are outdoors, pay attention to what kind of sunlight you find yourself in that day. Is it overcast or sunny? Overcast simply means that clouds are obstructing the sun. Overcast light is photography gold! We love overcast days because it means you can take pictures almost anywhere.

And what if it's bright and sunny? Direct sunlight tends to blow out photos, losing details and distorting colors. Also, if you are photographing people, it can be difficult to get a photo without the subject squinting—direct sunlight is bright, dude! If it's an ultra bright and sunny day, you can still get great photos. You just need to find some shade. This may be as simple as having your subjects lean back into the shade of a building. If you are taking candid pictures and you can't get your subjects into shade, take the photo anyway and see what you get. You may get lucky. But whenever possible, find some shade before snapping your photos.

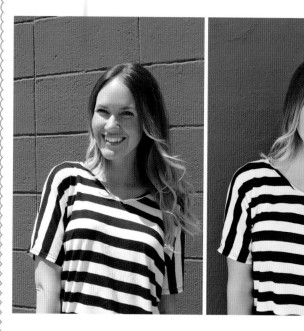

Here are two pairs of photos, each pair taken on the same day with one image in direct sunlight, the other in shade. Which looks better?

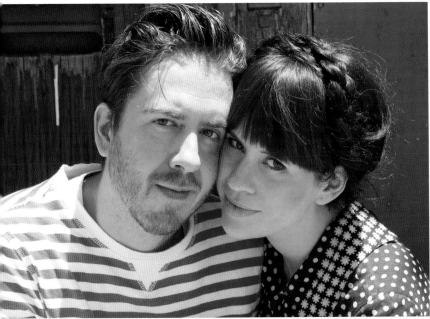

← yikes!

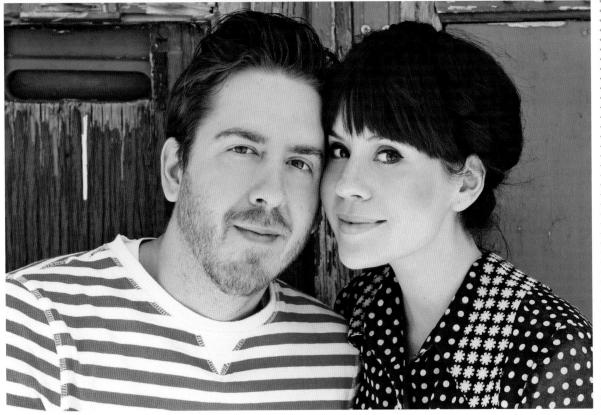

much
better

FIND FLATTERING WINDOW LIGHT

When you are photographing indoors, you still want to use whatever natural light you can find. Finding the most flattering window light is as simple as paying attention to angles, and it can make all the difference to your pictures.

Usually the best option is to have the subject face a window, with the photographer standing between the subject and the light source. Another good option is to have the subject stand adjacent to the window (just be sure to have them turn their face toward the light and not away from it). When working with window light, the rule is the more light on the subject, the better. Unless you are going for something artistic, of course—then by all means, break the rules!

Have your subject face a window to get beautiful light on her skin and eyes.

bad shadows

so much prettier!

Small changes
can make a big
difference when
it comes to light.
Here Emma
simply turned
her face toward
the window to
create a more
flattering photo.

TAKE PORTRAITS USING CHRISTMAS LIGHTS

Small Christmas lights can make your holiday photos feel special and intimate, perfect for couple portraits. Here are a few tips for using Christmas lights.

First, don't be afraid to string them all around your subjects. If you leave all the lights on the ground below your subjects, the effect can look somber and spooky. In general, lighting a subject from below is not very flattering. Also, it's best to have another, subtle light source in the room. If you turn off all the lights and the Christmas lights are your only light source, you'll likely end up with blurry images and lost detail. Better to be in a dim room with an open window or turn on a few shaded lamps in the background. Experiment when you are setting up the shot before you dive into the session.

For these photos of Elsie and Jeremy, dim window light was used as a secondary light source. It was a rainy day, so even though the window was open, the light was still dim enough to show off the glow from the Christmas lights. Photos by Arrow and Apple Photography.

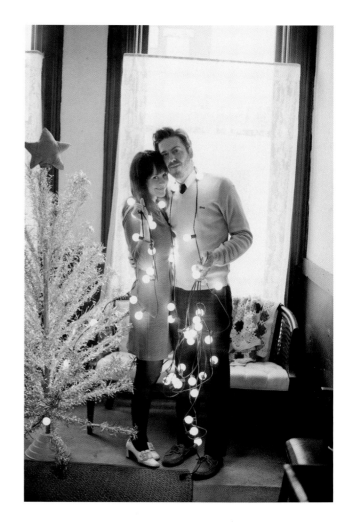

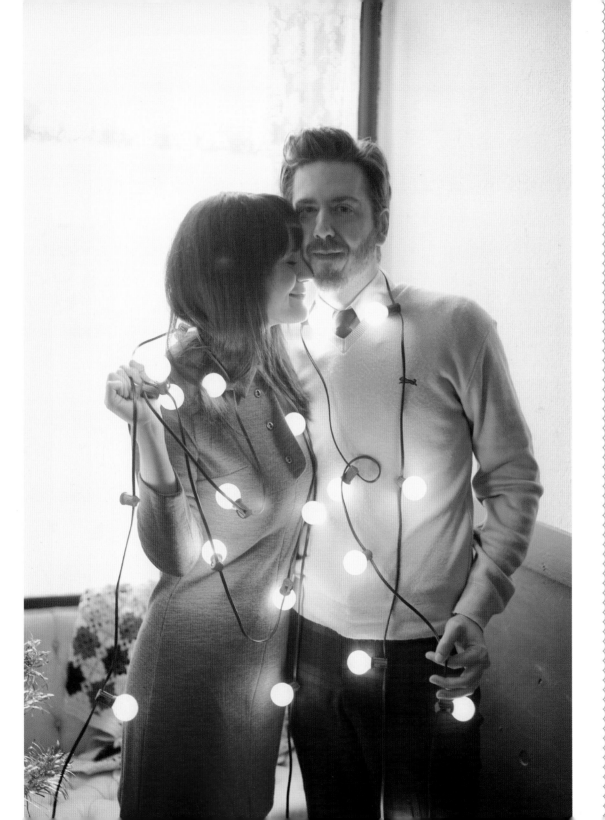

TAKE A SHADOW PORTRAIT

Shadow portraits are fun alternatives to traditional portraits. The basic idea is that instead of capturing a particular person or object, you capture the shadow instead.

There are just a few simple rules to keep in mind when trying shadow portraits. It's best to take shadow portraits in the early morning or late afternoon, when the sun is lower in the sky and casts long shadows. The higher the sun, the smaller your shadow will be. It can be quite difficult to get a shadow portrait in the middle of the day, when the sun is at its peak. Also, remember that these photos won't capture details, so the shape or gesture of the subject is very important. Some options that look great in shadow portraits are couples holding hands, pregnant ladies with protruding baby bumps (cute!), and subjects of varying heights. And don't forget to capture a little bit of the environment around you, too. Shadow portraits are perfect for walks on the beach, camping trips, and hiking dates.

Here's a shadow portrait of Emma and her boyfriend while on vacation in Hawaii.

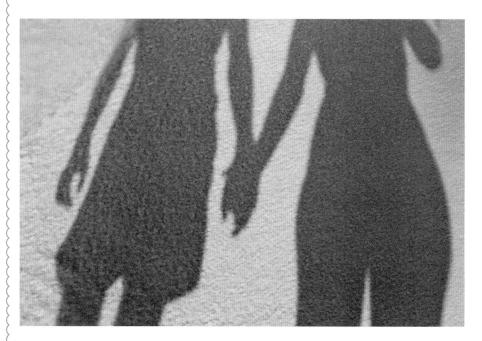

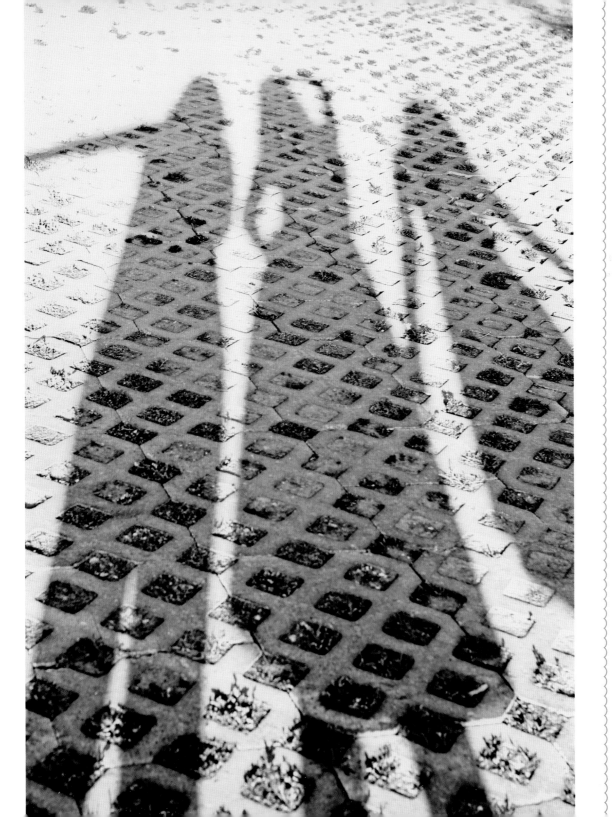

We snapped
this shadow
portrait just
before heading
to a girls'-night
dinner.

TAKE A SILHOUETTE PORTRAIT

Silhouette photos can be dramatic, artistic, and flattering. They are great for showing off personal details, such as profiles through the years or hair length as it changes.

Any kind of light source can be used to capture a silhouette, but it needs to be strong. If you are using window light, it needs to be a bright day. If you are using a lamp, it may work best to take the shade off.

The second most important requirement is to position your subject correctly. The light source must be *behind* the subject, with the photographer facing the subject. Think of it as a sandwich, with the light source on one end, the subject in the center, and the photographer on the other end. It is also best to center the subject in the middle of the light source, partially blocking it out, like a solar eclipse.

For a silhouette, the subject must be in the middle of the "sandwich," between the light source and the photographer. Here, the light source (a window) is in the back, the subject (Emma) is in the middle, and the photographer (Elsie) is in the front.

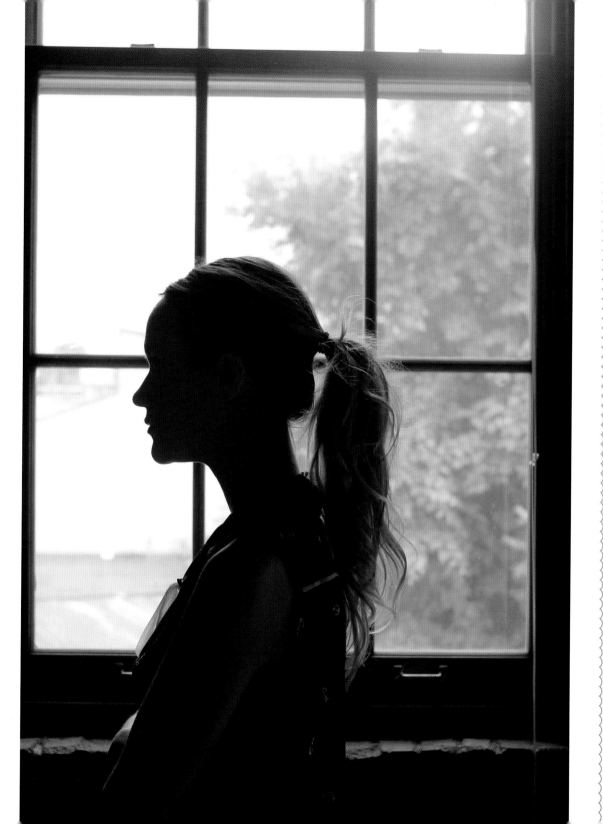

MAKE THE MOST OF SUN FLARE AND BACKLIGHTING

Sun flare and backlighting are two of our favorite lighting techniques because they create photos with so much feeling and atmosphere. Both of these effects work best in the early morning or late in the day, when the sun is either rising or setting.

Achieving great backlighting is similar to getting a silhouette (see page 64); you need to position your subject between the light source and the photographer. Once your subject is between you and the light source, have the person try different poses to allow the light to shine through his or her arms, hair, clothes,

and so on. We always have the best luck during the "magic hour," that time of day when the sun is beginning to rise or set. If the sun isn't quite low enough to hide behind your subject, try squatting down to take the photo (making your subject taller because of your lower position) or scouting out a hill or tall ledge on which to position your subject.

Most camera lenses are made of pieces of glass. As sunlight passes through the glass, it can cause reflections and other imperfections that result in *sun flares*. There are times when you don't want this kind of sunlight leaking through your photos, but we love the effect and go out of our way to capture it whenever possible. As with backlighting and silhouettes, you want to position your subject between the sun and the photographer. But this time, try having your subject move (or stay still as you move) to let the sunlight just barely peek over his or her shoulder or head, or over the horizon of a landscape (depending on what you are photographing). You will usually be able to see the sun flare in the viewfinder as you are photographing. This effect is very unpredictable, so have patience and try a bunch of positions. For another example of sun flare, see page 54.

Try different poses to allow light to leak through and create sun flare.

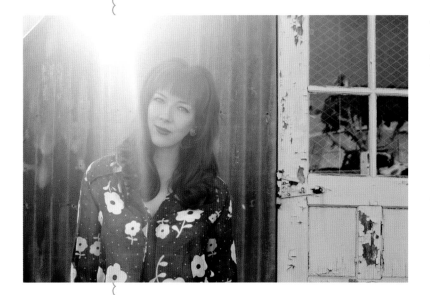

one of our favorite portrait tricks ↘

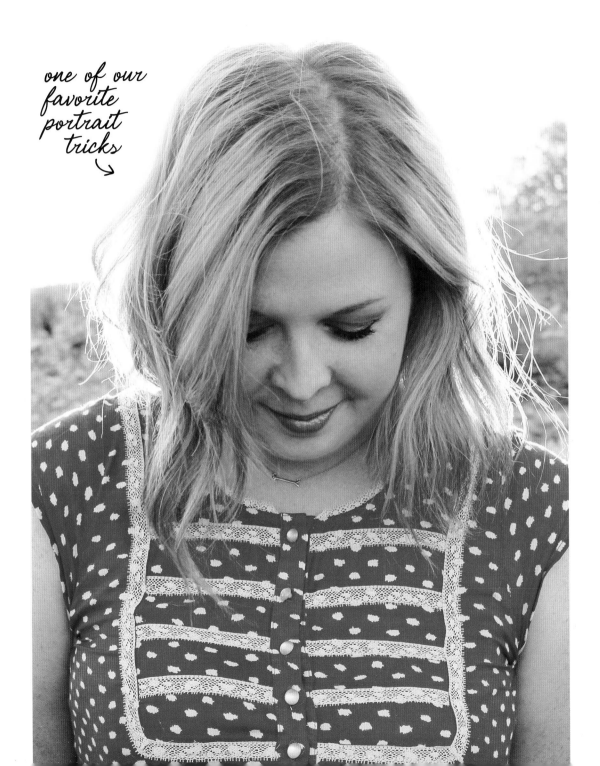

To get backlighting, place your subject between you and the light source. Here, our friend Sarah stands in front of a setting sun.

Overleaf: Try experimenting with backlighting half an hour before the sun sets.

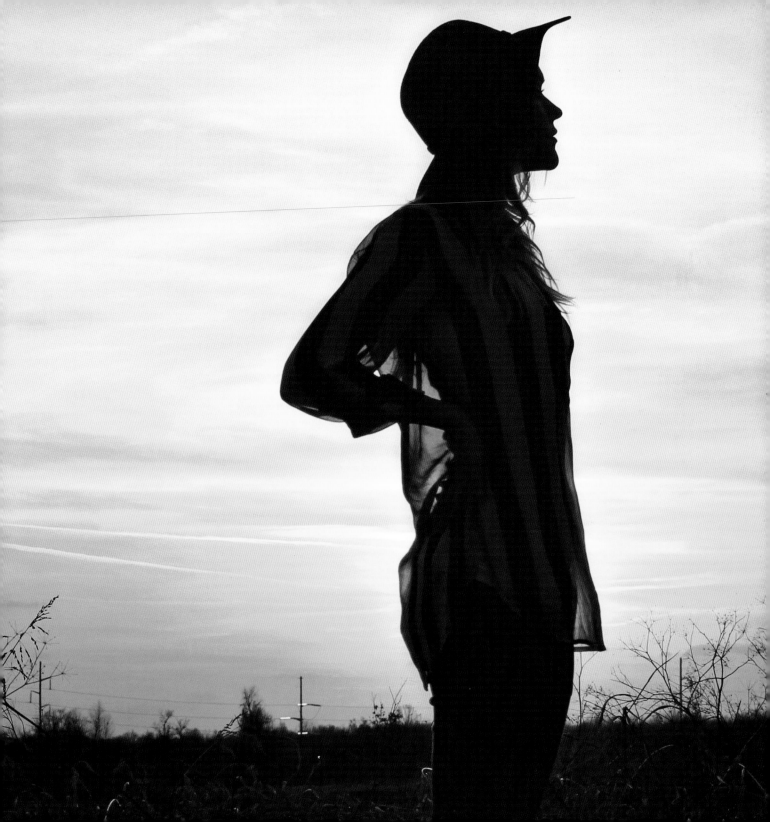

PHOTOGRAPH IN LOW LIGHT

Good lighting is essential for great photos. But this is real life, and sometimes you don't get to choose your lighting situation. We can think of so many times when we wanted to capture a special moment or event but it was late in the day or we were in a dimly lit room. Here are a few tips to help you get the best photos you can in low-light situations.

✳ **TURN YOUR FLASH OFF.** We know this sounds counterproductive, but just try it! We're not saying there is never a good moment to use a flash, but a general rule of thumb is to turn your flash off. Most of the time, a flash will blow out your photos, causing you to lose all detail, and force your subjects to close their eyes.

✳ **CHANGE YOUR SETTINGS.** Most cameras have automatic evening settings that make adjustments for you. If you're using a dSLR camera and are ready to start exploring your manual settings, increase your ISO. (Consult your camera manual if you've never done this before.) Try bumping the ISO up just a little, take a photo, and see what you think. If necessary, bump it up a little more. Just keep in mind that if you set it too high, your photos can end up looking grainy.

✳ **LOOK FOR WHATEVER LIGHT IS AVAILABLE.** Can you add more light without being distracting? This could be as simple as moving another lamp into the room at a family dinner or moving a few more candles to your table at a wedding reception.

✳ **DON'T BE AFRAID OF SLIGHTLY BLURRY OR GRAINY PICTURES.** Sometimes these can be beautiful and capture a certain feeling from the moment. When processing your pictures, try making them black and white, as this helps give low-light photos more contrast than they would have in color. Black and white can also be more forgiving if the color in your images is somehow off, or ugly.

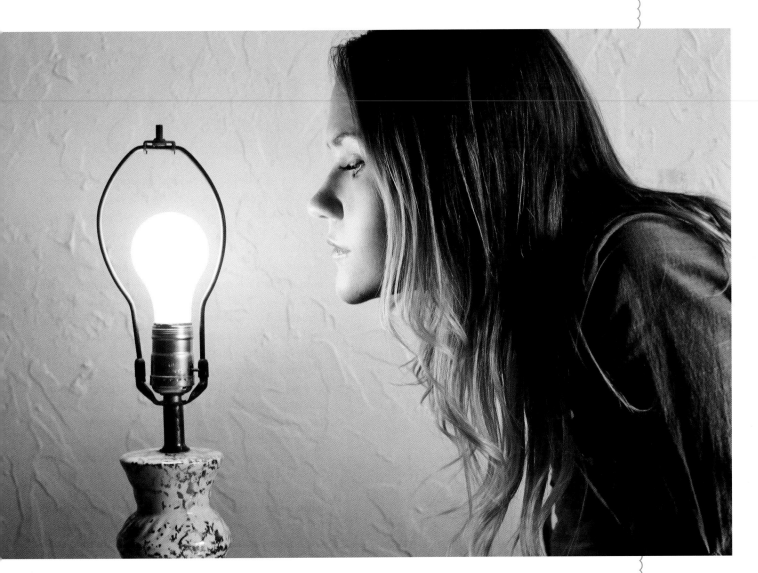

Try converting
low-light photos
to black and
white, which
is much more
forgiving.

MAKE AND USE REFLECTORS

Here you can see how Elsie holds the reflector to catch sunlight and bounce it back toward Emma.

Reflectors are objects that reflect light onto your subjects. This added light can make skin look glowing and flawless (thank you, light!). You can even used tinted reflectors to get a slightly different tone to your pictures. You may be intimidated by the idea of reflectors, thinking they're the type of tool only pro photographers use, but they're actually very simple to use. There are natural reflectors all around you in your environment, as well as inexpensive options for creating your own.

First, let's talk about naturally occurring reflectors. For example, if you are at the beach, you can use the water or sand as natural reflectors. Just have your subject angle his or her face or body toward the water or (white) sand to get more light on the subject. If you are photographing near a downtown area, white and light-colored walls can also be used as reflectors. Have your subject face the white wall, allowing sunlight to bounce off the wall and onto his or her face. Finding and using natural reflectors is another little thing to keep in mind as you scout for locations.

Another option is to make a reflector yourself. The simplest option is to buy a piece of white poster board or foam board from a craft or art shop. Boom. Now you have a ready-to-go, lightweight reflector for the low price of . . . well . . . almost nothing. To use it, have a friend hold it or prop it up on your bag (or any object), and move it around until it casts more light onto your subject. If you want to get fancy, cover a large piece of foam board in silver aluminum foil, gold foil from a craft store, or gold metallic fabric. These will not only add light but also cast an extra tone on your photos, giving them more depth and interest. Silver reflectors give your images a cooler tone (think blues), while gold reflectors give your photos a warmer tone (think yellows and reds). By the way, you can also buy reflectors at camera shops or over the Internet.

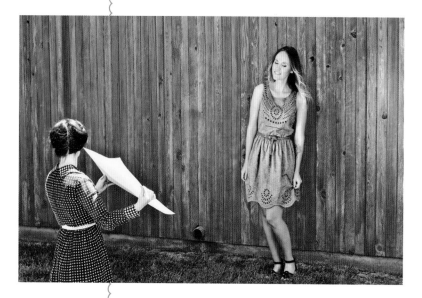

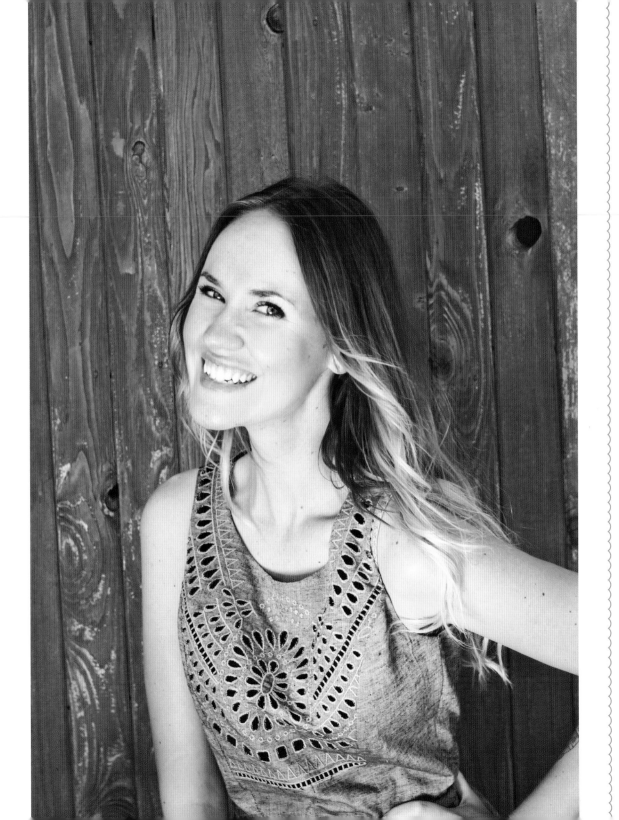

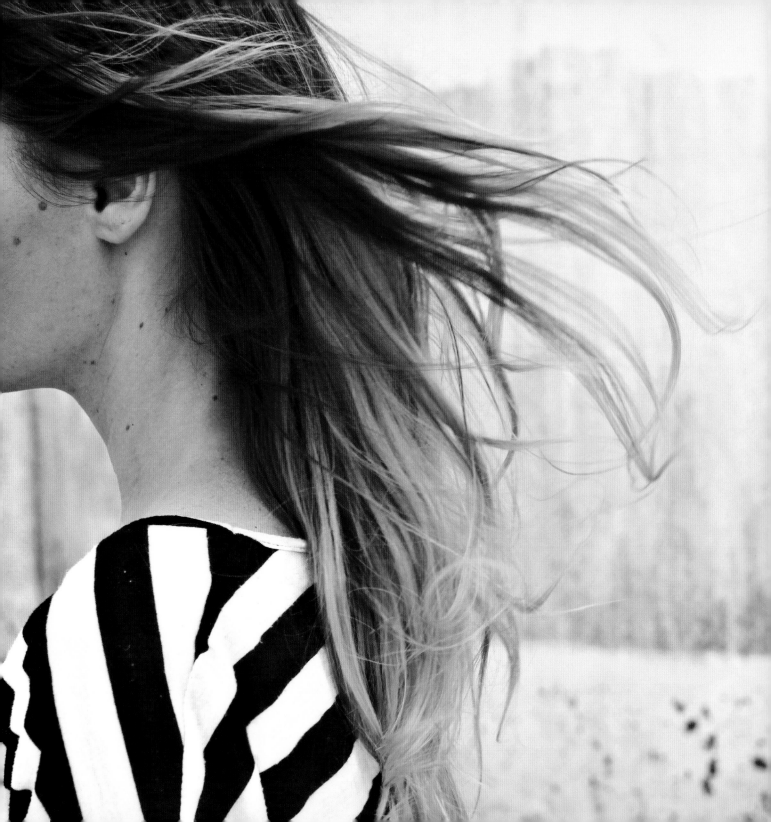

4
Get Creative

Whether you are taking your first photo or have been snapping away for years, it's easy to fall into a rut where you do the same thing over and over. Then suddenly it's no longer fun or exciting to take pictures and you're not motivated to pull your camera out during daily life. It happens; we've all been there. Over the years, we've both had times when photography started feeling stale. Usually this happens because you've fallen into a routine of taking the same photos over and over again or have stopped challenging yourself to try new things. Here are a few creative techniques to help you break out of these dry seasons! These ideas will get you trying new things and capturing pictures you wouldn't normally think to take, not to mention inspire other creative ideas brewing under the surface!

TAKE PERFECT PROFILE PICTURES

Profile pictures are great alternatives to straight-on face shots. They can be super flattering and often feel more dramatic and special because they have a little bit of mystery, since your subject is looking off to the side.

To set up a profile photo, ask your subject to stand in front of a simple background. You don't want your background to be too busy or distracting for this type of photo, but feel free to spice it up with your color or texture choices. Have your subject face the light source to leave as few shadows on his or her face as possible.

Take a few photos and see what you think. Ask your subject to slightly raise or lower his or her chin. Find whatever position is the most flattering. Keep trying slightly different angles and expressions until you get what you like.

Opposite: We had Stacy face the window for this profile picture, lighting up her facial details and some of the glitter behind her.

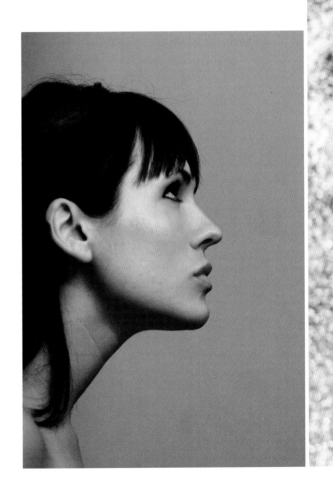

Elsie took this self-portrait in a mirror, after a lot of practice shots.

*highlight your profile
by facing the window*

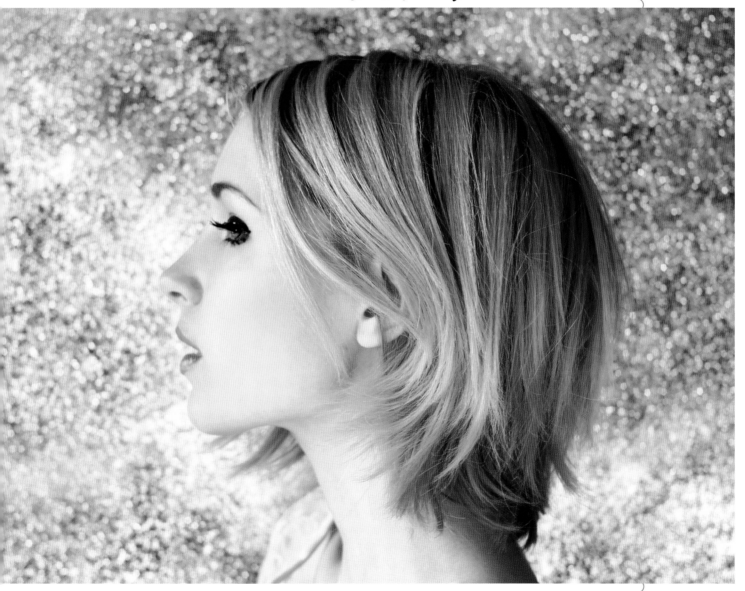

PHOTOGRAPH MOTION (PART 1): MOVING OBJECTS

Getting a photo of your subject with moving objects around him or her is a great way to capture a busy or active environment. Examples include cars driving by, other pedestrians pushing past your subject on a busy street, or water rushing around your still subject.

The best way to capture an image like this is to use a dSLR camera and adjust your shutter speed. *Shutter speed* controls how long your exposure will be—meaning how long your camera's shutter stays open to capture an image. The longer the shutter stays open, the more any movement will be recorded as blur. (The shorter it stays open, the more motion will be "frozen.") Choosing the right shutter speed depends on your situation. Start by setting it to 1 second and take a photo. Do you want more blur? If so, slow the shutter speed to 2 seconds. By the way, it is absolutely essential that your subject hold still while you take the photo. You want the background to have motion, but not your subject.

Whenever you use a longer exposure, it is best to use a tripod or flat surface to set your camera on so you don't shake it. If you don't have one available, pull your arms in to your sides and hold as still as you can while you photograph. Just before you snap a photo, exhale and center yourself. We've seen great results both with and without a tripod, so never be afraid to try.

If you aren't using a dSLR or don't want to adjust your shutter speed, try photographing late in the day when the sun is setting. We took this photo of Emma in front of moving traffic without adjusting our shutter speed. The reason it worked was that we had our camera set on auto and it was late in the day, when there is less available light. This forced the camera to automatically slow its exposure time to let in more light. Of course, this last technique is very experimental and will probably require a lot of takes before you get the perfect photo.

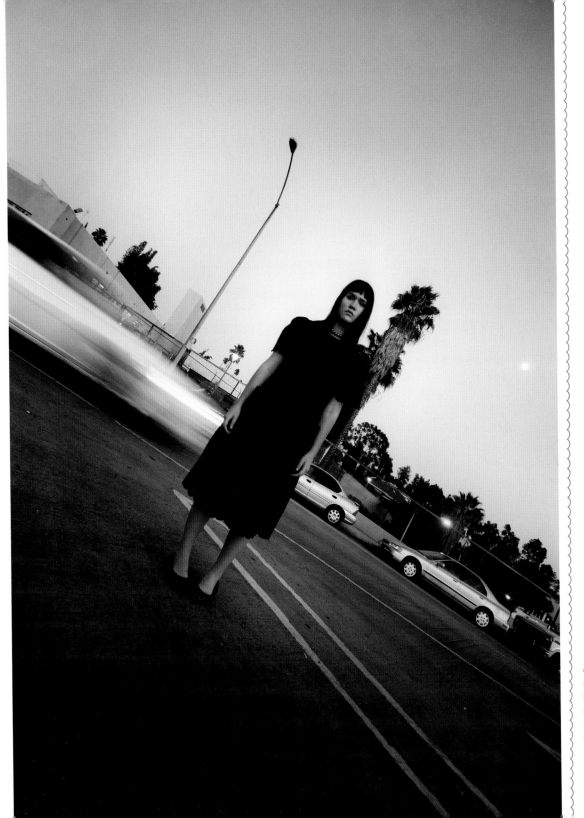

Capturing moving objects behind your subject can make a picture feel alive.

PHOTOGRAPH MOTION (PART 2): WIND

Wind can be frustrating when you are out taking pictures. It can blow over props, mess up hairdos, and (most embarrassing of all) blow up skirts. We'll be the first to admit that wind can be a nuisance when all you want is a pretty picture. But. Wind can also add a lot of life and beauty to your images if you work with it and not against it.

To make the most of wind, be intentional with your styling choices. If your subject has long hair, ask her to wear it down so it will move with the wind. Have your subject wear loose, flowing fabrics, especially medium and long dresses (wear short skirts at your own risk!). Let the wind do its thing as you snap away. Experiment with different poses: so the wind blows her hair behind her, then in front of her face, and so on. Pay attention to the facial gestures your subject makes. Not every photo will turn out flattering, but if you give yourself a lot of options, wind can be a photo friend after all!

Choose loose clothing for pretty wind pictures.

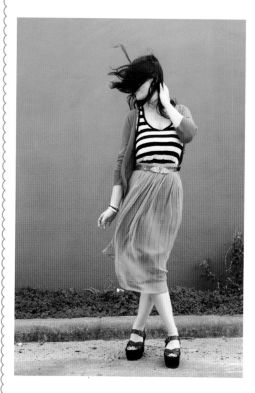

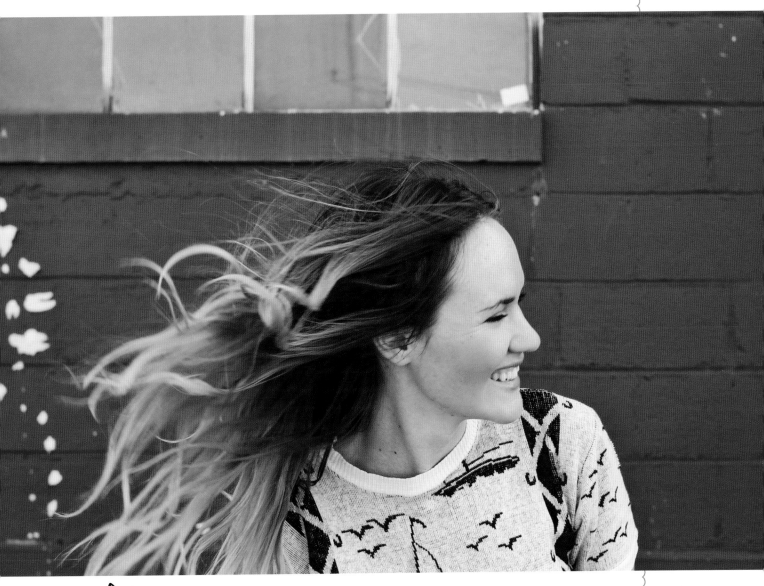

↖ *be patient! wait for*
the perfect windy moment

Wind can
breathe life into
an otherwise
ho-hum photo.

PHOTOGRAPH MOTION (PART 3): JUMPING

Action shots can be fun and add a lot of personality to your pictures. These are great options for kids or for groups of friends. Sometimes you can get organic action shots at sporting events or at the park.

To set up a jumping portrait, think about a good location. It can be easier on your subjects if they have a small step or stoop of some kind to jump off. Make sure you like the background and that your subjects will be safe (have them wear jumpable shoes if needed!). Be sure your subjects are wearing clothes they feel comfortable jumping in and can safely move in. Never try to force someone to do a jumping portrait if he or she isn't into it. Jumping body + angry face = weird photo.

Be sure to keep taking shots until your subjects are tired of jumping. Not every photo will have the perfect facial expression, and some will probably turn out blurry. So give yourself the freedom to take a bunch and choose the best.

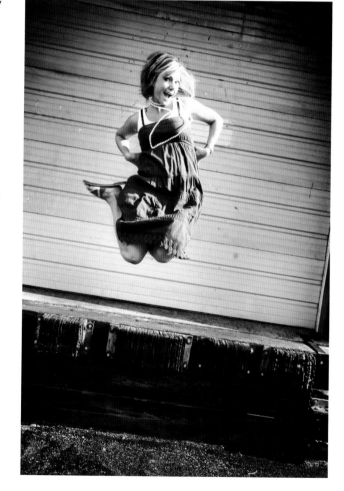

Amy demonstrates the classic jumping portrait. Go, Amy!

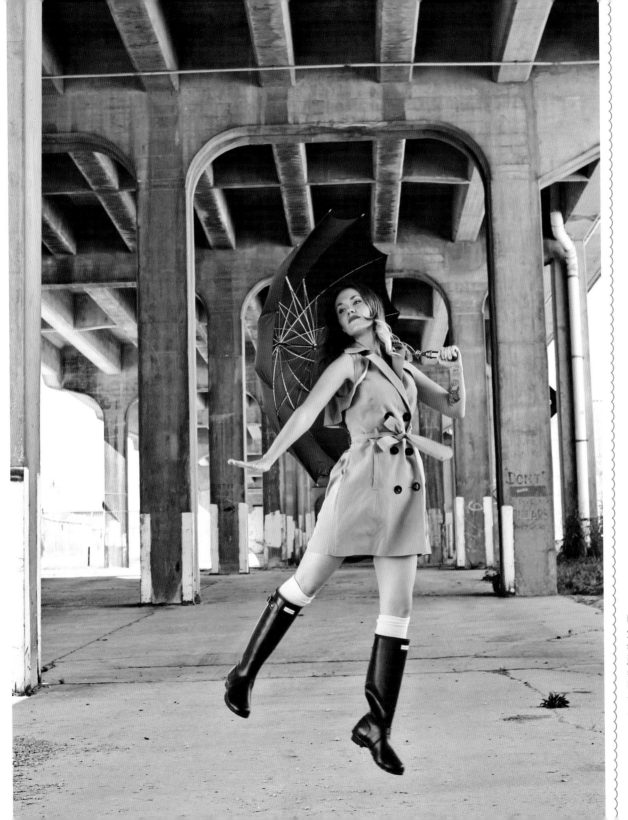

If you find
yourself the
subject of a
jumping portrait
session, don't
be afraid to go
for it! These
are meant to
be fun and
lighthearted.

TAKE WIDE PHOTOS

We so often focus on details, filling the entire frame of our photo with the subject. It can be a great challenge to take wide photos, which force us to be more intentional about how we get viewers to notice our subject. Remember, you almost always want to highlight only one special feature in each photo. What do you want your viewer to see first? You can highlight this subject by how you crop the photo, where you place it in the frame, or through lighting.

Great times to try to get wide photos are when you are in a special environment you want to capture, such as the beach or hiking in the mountains. (Landscape photography can be a fun change of pace if you usually photograph people and objects.) Another reason to take wide photos is to incorporate negative space. *Negative space* is the space around your subject. Having a lot of negative space adds tension to a photo, forcing the viewer to note the subject first.

Maybe you want to highlight your subject by leaving him or her in the lower third of the photo, with the rest a textured wall. This type of photo can be really pretty and different. This is also great if you plan to add text to the photo later for your blog or photo album.

Isolate your subject by taking a wide photo.

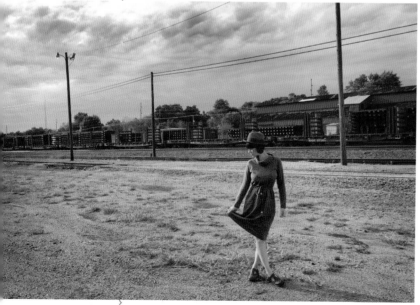

← *wide-angle lens*

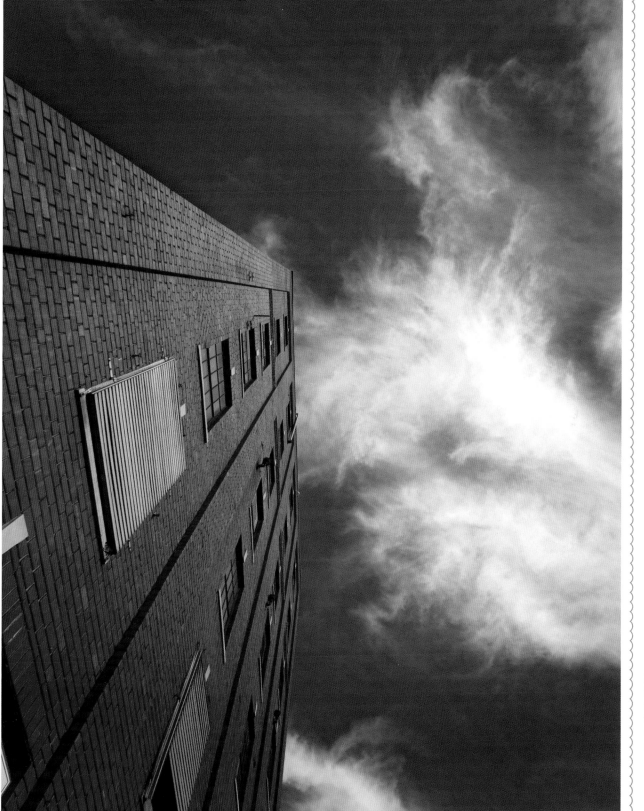

Notice the tension and atmosphere in this wide photo of a building and sky.

TAKE ARTISTICALLY BLURRY PHOTOS

n general, most of us want our photos to be crisp and clear; blurry photos are usually viewed as mistakes. But every once in a while, a blurry photo can be beautiful. To take a blurry photo on purpose, you can either set your camera to manual mode and blur your point of focus, or, if your camera doesn't have manual mode, try moving slightly as you snap the photo. Either way, it may take a bit of practice to get the amount of blur that you want.

When you choose to take a blurry photo, you are trying to capture a feeling more than a specific feature or image. The best blurry subjects are striking images that convey messages all on their own, such as a couple holding hands, snow falling on a tree, a baby reaching up to its mother, and so on. It's best not to photograph faces with this technique as the results can be unflattering. Instead, focus on gestures and body language, or landscapes.

Blur can be used to create dreamy, romantic landscapes.

We set our camera to manual and took a few blurry photos of Darren and Stacy holding hands.

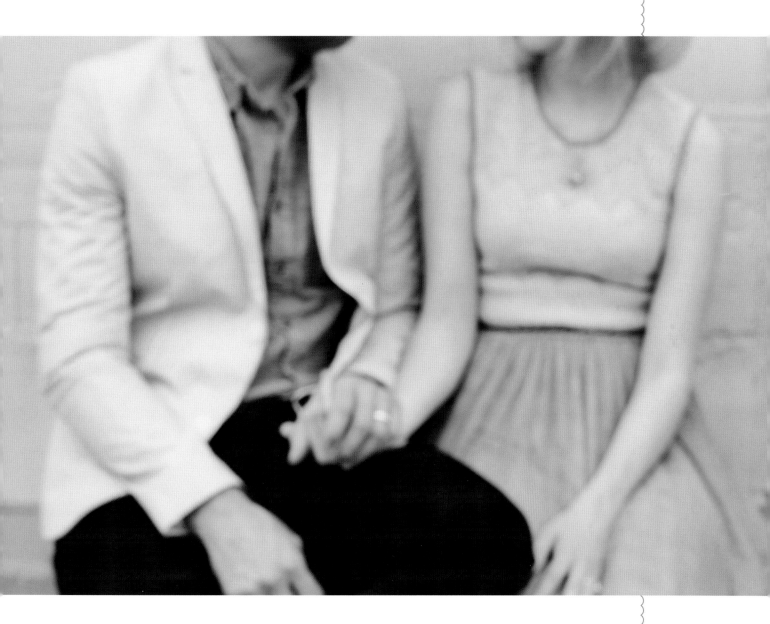

TAKE MACRO PHOTOS

Experiment with different angles and perspectives when you're shooting details, such as photographing from above.

Macro photos are extremely close-up photos of features or objects. There are special macro lenses you can buy for dSLR cameras; we have one we love (see page 239 for details). But you don't need special equipment to get pretty macro photos. Here are a few tips to think about as you explore the world up close and personal.

Macro photos need a sharp point of focus, either the entire subject or, if you're super close, just the most important point of the subject, with the rest blurry. This is easiest to achieve with your camera set to manual, but with practice and patience you can get good results using your auto setting or with a camera phone. Choose subjects with a lot of different colors or texture. Often macro photos can be so zoomed in that you can no longer tell what the picture is of, and that's okay! As long as you are being intentional it can be interesting to get a close-up photo of almost anything.

*zoom in ↗
to discover
pretty details*

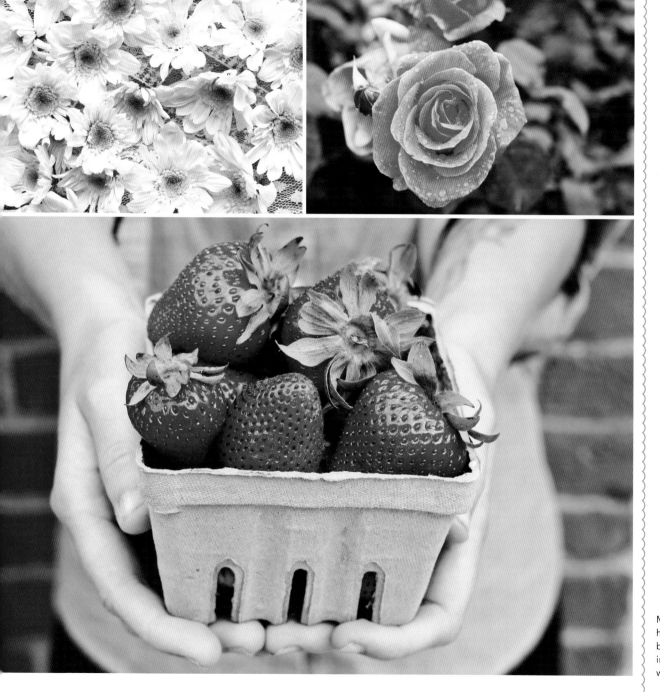

Macro photos
highlight the
beautiful details
in our everyday
world!

CREATE ATMOSPHERE

Typically when we photograph, we simply capture the world around us, as it is. But another approach is to create atmosphere in your photos, setting up your shot to convey tension or specific emotions. You are still working with the natural environment, but being more intentional about how you photograph it. Here are three tips for creating atmosphere.

✳ **PAY ATTENTION TO SPACE.** How you frame (or crop) a photo greatly affects the message it conveys. For example, if you leave a lot of empty space around your subject (maybe he or she is standing in a wide open field, or against a large wall), this creates a strong focal point. The viewer will immediately look at the subject, making him or her the central focus of the photo.

✳ **USE COLOR.** Certain colors give off feelings: yellow and orange feel happy, blue and black feel calm or (sometimes) sad. Choose to focus on certain colors to give your photos a more emotional feeling.

✳ **USE CONTRAST.** Contrasting colors, textures, patterns, and subject matter can make your photos feel more alive and energetic.

Opposite, top: We photographed these lattes at a local coffee shop that has a large window and cute yellow chairs—elements that could easily make our photo feel happy, bright, and cheery. For a challenge, we tried instead to convey a feeling of calm. We moved the lattes away from the bright window to a wooden coffee table with more subdued light and neutral colors.

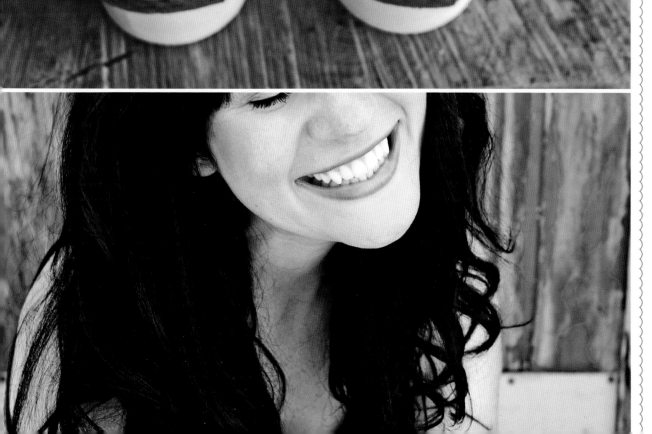

The contrast of Elsie's black hair and fair skin against a bright blue wall add energy to this photo.

use a monochromatic
color scheme to create
soft and airy atmosphere
in your photos

UNDERSTAND DEPTH OF FIELD

epth of field refers to the amount of your photo that is in focus. If all of your photo is in focus, from front to back, it's called a *deep* depth of field. If only a small part of your photo is in focus, such as the subject, and the background is blurry, that's called a *shallow* depth of field.

Depending on what kind of camera you use, you may have more or less control over your depth of field. With a dSLR camera, you can manipulate your *aperture* and *focal distance* to control depth of field. If you use a larger aperture (smaller f-stop number) and a closer focusing distance, you'll create a blurry background (shallow depth of field), which is great for taking portraits. If you have never played around with f-stops on your dSLR, consult your camera manual to see how to adjust your specific camera.

If you are not using a dSLR or don't want to mess with your f-stop, here's a fun challenge. Photograph a person with his or her back directly against a wall. This will create the look of a deep depth of field, where everything is in focus. Then have the subject move three or four feet (or more) away from the wall to create the illusion of a shallow depth of field, with the wall in the background falling into blur.

You can manipulate depth of field even with an iPhone camera by having your subject stand close to and then farther away from a wall. In the top example, everything is in focus (deep depth of field); in the bottom example, the wall becomes blurry (shallow depth of field), making Emma really pop.

MAKE HOMEMADE FILTERS

Wouldn't it be fun to explore the world through a new set of eyes? Homemade filters can do just that—they are a super fun and inexpensive way to change up your photos, no Photoshop needed! Camera filters are transparent (or translucent) elements that alter the quality of the light as it enters your camera, distorting the image. Homemade filters can be made out of all sorts of materials for different looks. Here are our three favorite ideas.

✳ **LACE.** Add a thin layer of lace or tulle in front of your lens while photographing. Choose lace that your camera will be able to focus through. If you have trouble getting your camera to focus on your subject and not on the lace, cut a small hole in the lace, which can make the edges of your photo look cloudy.

✳ **SUNGLASSES.** Focus through the lens of your sunglasses or a piece of colored transparency paper. This will cause your photos to take on a different range of colors.

✳ **SARAN WRAP AND VASELINE.** This is our current favorite. Tightly wrap your camera lens in Saran wrap and secure it with a rubber band (or simply hold it in place as you photograph). Now smear Vaseline on the Saran wrap, circling the lens center. Leave a small area for the camera to focus through. This filter will give your pictures a very blurred outer edge, giving them a dreamy, ghostly feeling. Weird, but fun!

When trying the Saran-wrap-and-Vaseline technique, take care not to smudge your actual lens!

cool toy camera effect!

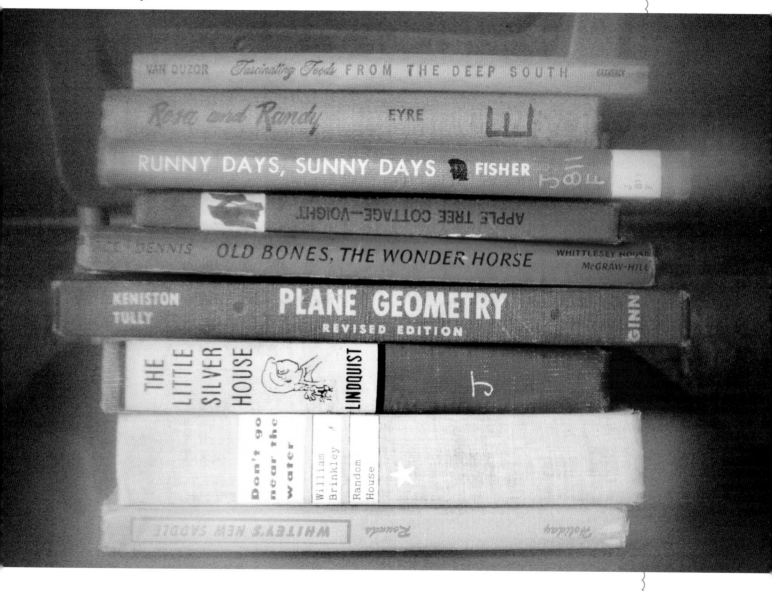

ADD HAND COLORING

Hand coloring adds a vintage vibe to any photo.

Hand coloring is a retro technique that was used before digital photography. There are ways to do this with photo editing software, but we love the vintage vibe and variety of colors you can get when doing it by hand. Also, no special equipment is needed—you can use everyday paintbrushes and acrylic paints from any craft or art supply store.

First, print a few black-and-white photos. You can use a variety of papers for these prints, but we don't recommend high gloss as the paint will have a hard time absorbing and is more likely to smear during the process. For paints, we like acrylics because they are inexpensive and easy to mix to create our own custom colors. Oil paints are the traditional option, but they are often more expensive and take longer to dry. You can also use colored pencils and a little oil (such as canola or vegetable oil). Simply color the areas you want and then lightly dab on oil with a cotton ball to blend the color.

Remember to start light; you can always add more color later, but it's much harder to take color out if it's too dark. And feel free to color outside the lines! There are no rules, so if you want to paint a tree blue and the grass pink, then do. Have fun and create something you love.

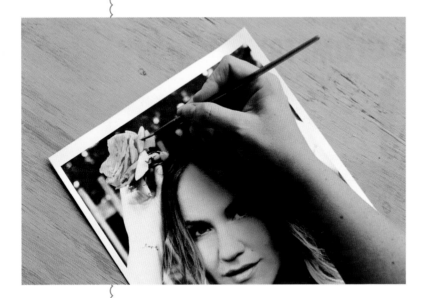

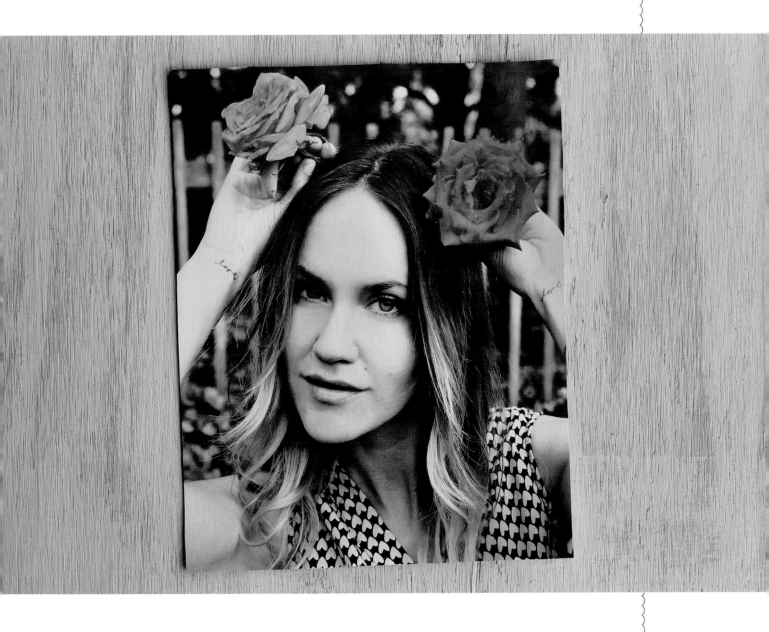

5

Get Inspired

We are big believers that it is the little things in life that make it special. Our lives are made up of a ton of little moments and seemingly mundane events. Often these everyday things get overlooked in photography because we are so used to them or feel they don't warrant a photo. But we challenge you to never think of *any* beautiful photos as a waste. Instead, let your everyday experiences and surroundings inspire you to document your life. In the process, it may make you thankful for all the little things: added bonus!

TAKE AMAZING PHOTOS OF YOUR HOME

Home is where we cook family dinners, where children take their first steps, where we host game nights and throw birthday parties. Our home is where we retreat when we've had a bad day. Save the memories of this special place by taking the time to show off your home in photos.

✳ **CLEAN UP.** We've heard it said that it's unrealistic to take photos of your home while it's perfectly cleaned and styled. And we agree! Our homes are not perfectly clean all the time; we're not Stepford wives. But you wouldn't show up to your bridal portrait session with wet hair and last night's makeup, would you? Why not photograph your house looking its best, too. If it's overwhelming to have your entire house photo ready, just do it one room at a time.

As you photograph, look at your images for things such as the corner of a dusty ceiling fan or electrical cords popping out from behind your entertainment center. We don't usually notice details like this in real life, but in a photo they can really take away from your focal point.

✳ **USE NATURAL LIGHT ON A SUNNY DAY.** You want your home to feel open and inviting, not dark and dingy. Pull back the curtains or open a door while you snap away. Photograph earlier in the day, and don't wait until the sun is low in the sky because it could cast shadows that would distract viewers from your fancy wallpaper.

✳ **TRY BOTH WIDE SHOTS AND CLOSE-UP SHOTS.** Not every room will look its best in a wide-angle picture. Most homes have corners or narrow hallways that can be distracting in a photo. There are times when you should stick to photographing one wall at a time, or even a smaller area such as a mini wall display you have created.

✳ **STYLE YOUR PHOTOS.** Set up a few staged areas to show how a room is used. This could mean placing a pair of shoes artfully on the floor of your closet, or having a few dishes set out to "dry." If possible, include your family and pets in a few shots, too. You want your home to looked lived in, but still pretty.

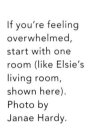

If you're feeling overwhelmed, start with one room (like Elsie's living room, shown here). Photo by Janae Hardy.

Having people in your photos will make your home look more lived in. Photo by Janae Hardy.

Pages 104 and 105: Don't forget to take detail shots when you photograph a room. Photos by Janae Hardy.

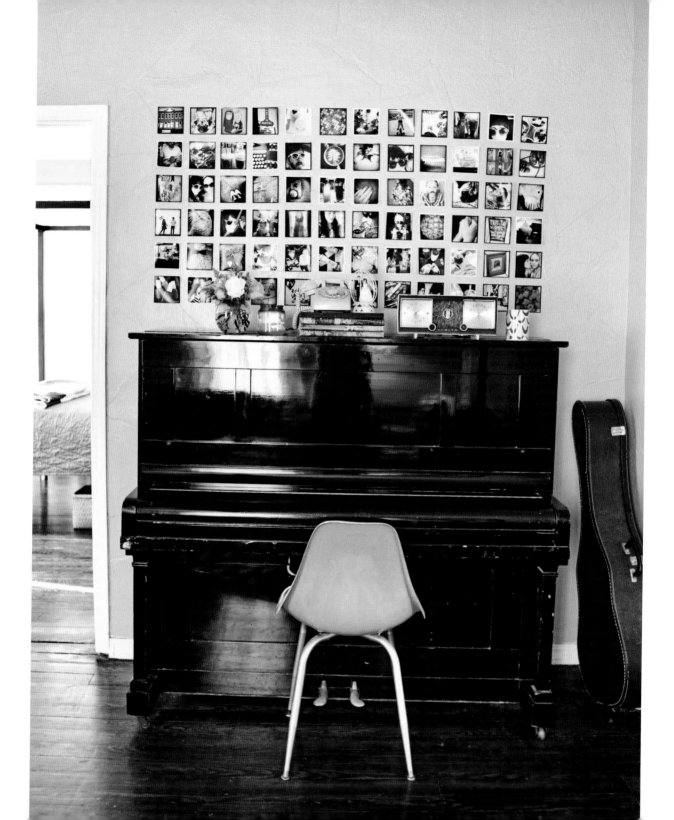

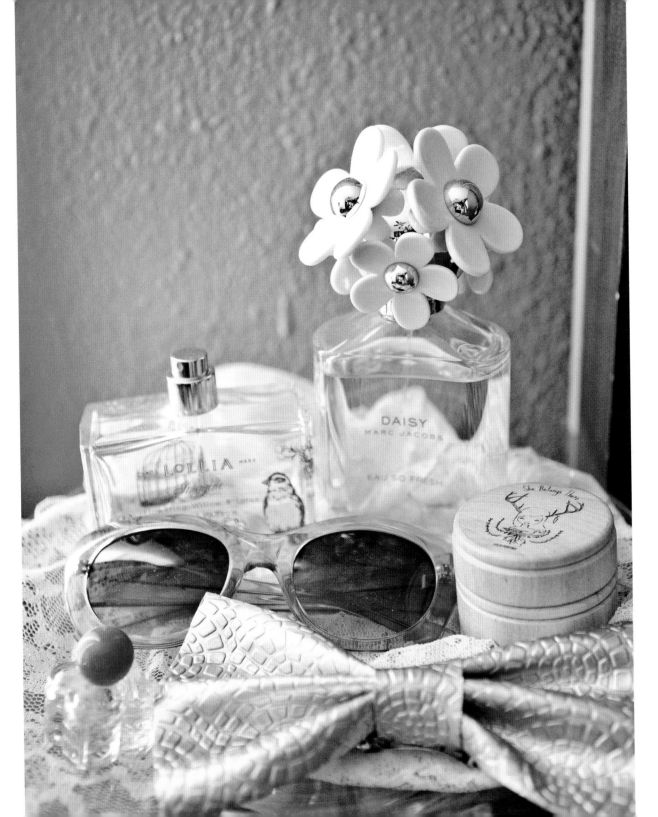

PHOTOGRAPH A COLLECTION

You may not think of yourself as a collector, but chances are there is something you enjoy collecting. This doesn't have to be something as traditional as playing cards or old vintage radios. Maybe you don't collect thimbles from every U.S. state, but you have a growing cookbook (or shoe!) collection. It can be fun to find creative ways to photograph these items because you may not have them forever. Maybe your daughter collects My Little Ponies; why not save this memory through a photo?

Set up a photo of your collection in the area of your house or office where they are kept. You could organize the collection in a pattern or display, but don't be afraid to snap a few messy photos, too. Try different angles and see what looks the most flattering. Try photographing the collection at different times of day—sometimes early-morning or early-evening light can change the light in your home depending on which way the room faces.

a peek at our vast shoe collection! →

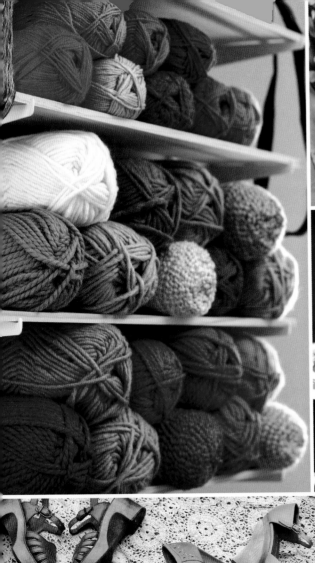

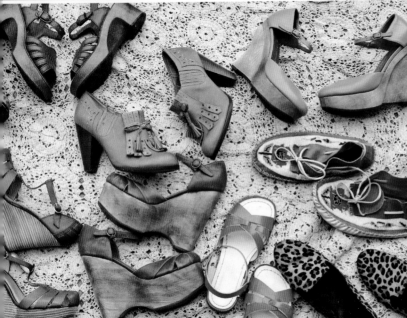

We are both crafters, and showing our collection of materials can be both personal and colorful.

CAPTURE YOUR DAILY ROUTINES

The little routines and rituals we set up in our lives are important, giving life structure and bringing us comfort. Having photos of all these little memories are fun to look back on years later; maybe to laugh at ourselves for being obsessed with certain things, or to remember what was important to us during a specific season in life. Whatever the case, don't be afraid to photograph your daily routines.

Make a point this week to note your special daily routines and rituals. Remember to bring your camera (or camera phone) the next time so you can document the event. Try a few different angles, zoom in, and try looking at your surroundings in a new way. There is no such thing as a silly picture when you're out to document your life. Maybe no one else will value photos of your coffee dates, but if it means something to you, snap a photo!

Elsie and Jeremy have been getting together for coffee almost every day since they started dating.

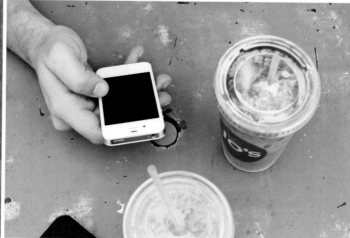

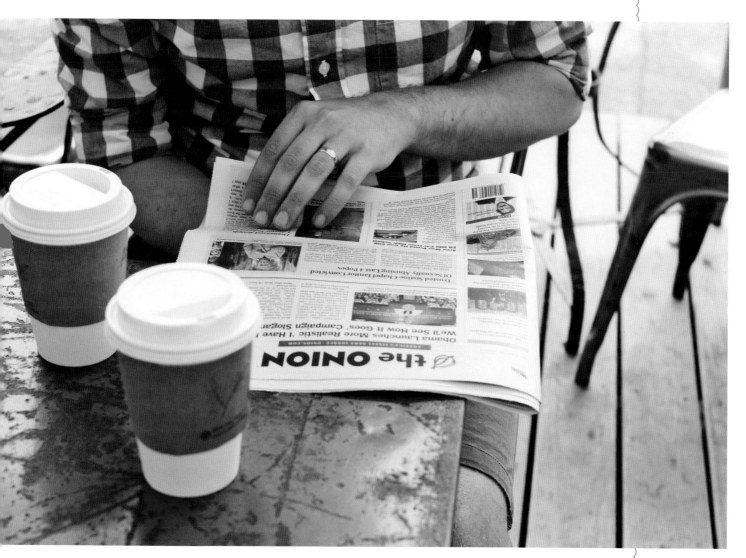

our favorite routine

CAPTURE SEASONAL DETAILS

We are lucky in that we grew up and currently reside in southern Missouri. We experience the four seasons every year, and for us they mark the passage of time. Not every region of the world has dramatic seasonal changes like our neck of the woods, but most of us have at least some seasonal shifts. Finding creative ways to document them can be a fun challenge for any photographer.

Maybe you want to photograph the changing leaves on the trees in your neighborhood, the winter's first snow, or a sunglasses-and-frozen-yogurt moment in summer. Having these photos in your album or framed on your wall can remind you about what season it was when you started college, got married, or bought your first home. It's not that we would forget these details without the photos, but there's something special about having them represented in our pictures. Enjoy every season!

It's also a good idea to pay attention to seasonal colors. When we think of fall, we think of burnt orange or bright red because those are the colors the leaves become in our hometown. Seek out and capture vivid colors that mean something to whatever season you are experiencing.

Capture the palette of each season where you live, such as the bright reds and oranges of fall in the Midwest.

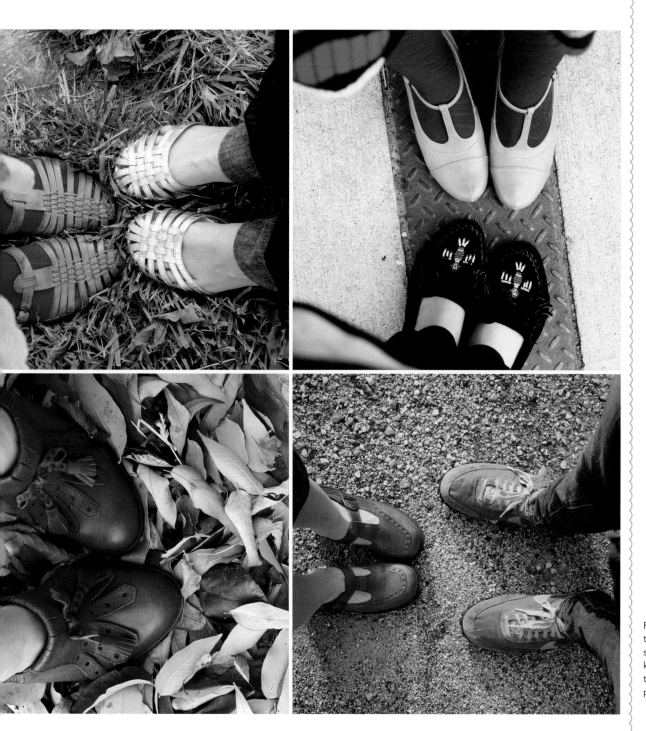

Pay attention to the passing seasons and keep track of them through photos.

CAPTURE YOUR LIFE AT SCHOOL OR WORK

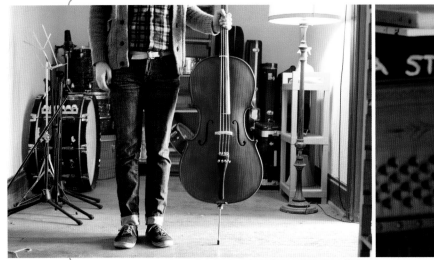
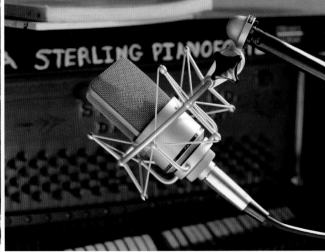
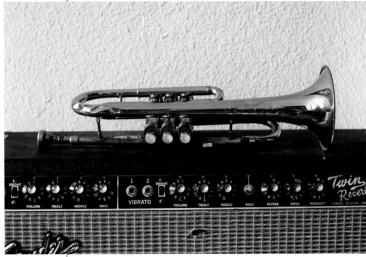

For us, the classic example of capturing life at school is how our mom used to snap a photo of us on the first day of school every year. The photos were always taken in our front yard before we got on the school bus. We usually have on our backpacks or a lunch pail in hand, and you can see what we chose to wear. These photos may be considered cheesy, but oh, how we love our mom for taking them! They are so much fun to look at and remember, and we can't wait to show them to our kids someday.

Capturing your life at school or work is still important as an adult; it's where we spend the majority of our time. For example, our grandfather owned a furniture store most of his life. He retired some years ago, but all of us grandkids have memories of playing in our grandpa's store. I love seeing old photos of him at his furniture store because it was such a big part of his life. Maybe you don't feel like a photo of you at your office is very exciting, but remember that finding a creative and beautiful way to capture this part of our lives may be important to us (or our loved ones) later on down the road.

← we love this musical workspace

Opposite:
Jeremy creates beautiful music in his studio above our shop every day.

Overleaf:
The two of us at work in our shop, Red Velvet.

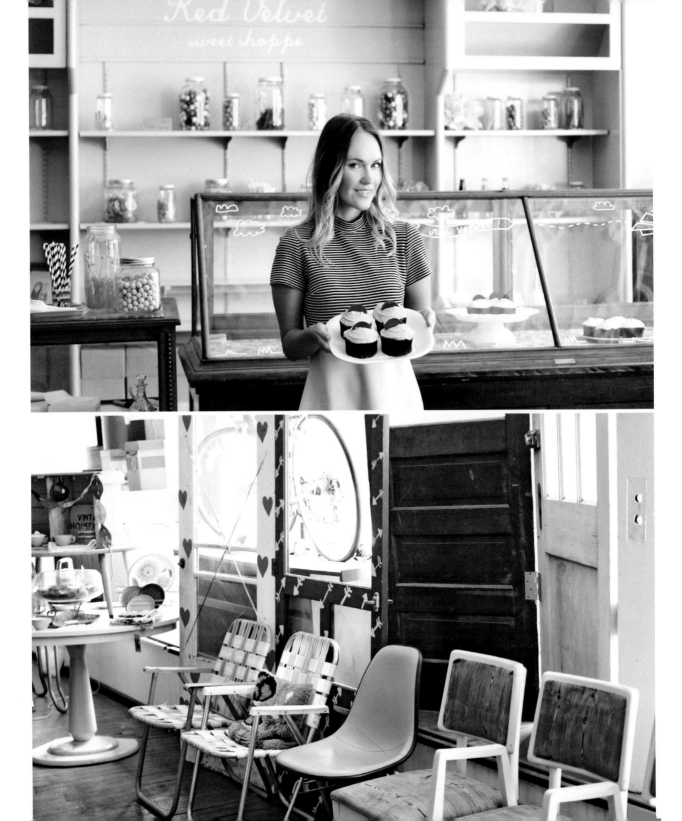

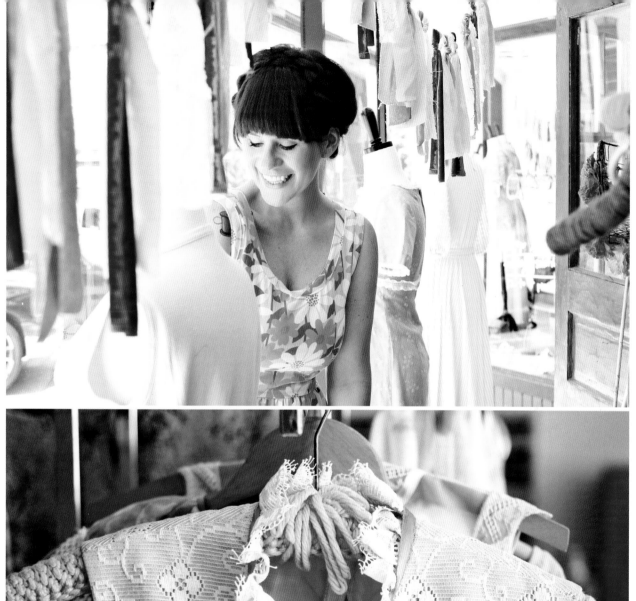

PHOTOGRAPH YOUR DAILY OUTFITS

t's no secret that we love fashion! Most of us take time to choose our clothes—why not take a little time to document your outfits? We've been photographing our outfits for years and are often asked if we feel silly posing for them. The answer is *yes*! Unless you are a professional model, you probably won't feel comfortable posing by yourself in your favorite outfits. Don't worry—we didn't either, especially not at first. But over the years, we've found that this practice of taking outfit photos has helped us feel more confident and comfortable with our style. Here are five tips for taking the best outfit photos.

✳ **USE REAL PROPS.** Having something to hold or carry can really help you loosen up. This can be as simple as holding your purse, or you could try riding a bike or holding a coffee cup.

✳ **TRY DIFFERENT ANGLES.** Whether you're using a tripod or having a friend snap photos for you, try getting different angles to see what works best. We all have different body types and features that we like and don't like. Try angling the camera lower, so the shots of you are angled up. This is our favorite way to be photographed because, honestly, we're not the tallest ladies in the land. Other folks prefer to be photographed from a higher angle, which has other advantages.

✳ **DEVELOP YOUR PERSONAL STYLE.** We love how taking outfit photos has pushed us both to develop our styles. It's easy to shop and just buy something you like. It's much more intentional and interesting to cultivate a specific style. Don't worry about wearing things others will approve of. Wear what you love and show off your personality and unique perspective with your outfits.

✳ **TRY DIFFERENT POSES.** It's great to get full-body photos where you're smiling, but don't be afraid to get creative! Take close-up shots of just your shoes or the pattern of your skirt. Try holding your hands differently or sitting down, walking, and so on. Take chances and spice up your poses.

✳ **TAKE A LOT OF PHOTOS!** Especially during your first few sessions, take two to three times as many photos as you plan to use. This will help you feel less pressure, give you lots of options, and allow you to keep only the very best shots. If you don't like a session, learn from it and then scrap it! You don't have to keep or use any photos that you don't like. The more you take, the better you will get. Practice makes perfect, dude.

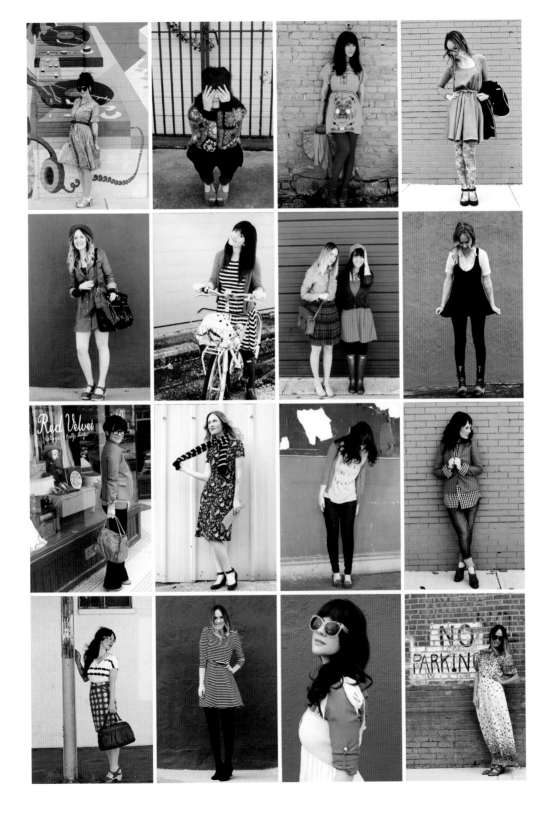

Feeling confident when being photographed takes time and practice. Don't shy away from photographing your outfits if *you* want to.

CAPTURE YOUR HOBBIES AND INTERESTS

Find the beautiful aspects of your hobby.

We know what you're thinking: "My hobby is knitting. So, like, how can I get a photo of my knitting project without it being totally boring?" Great question! Here are three tips for creating more diverse hobby photo sessions.

❉ **PHOTOGRAPH YOUR PROJECTS IN STAGES.** Are you into home improvement projects? Take before-and-after photos of your bathroom sink makeover. Like baking? Take photos of the raw ingredients and then a finished photo of your magnificent creation.

❉ **CAPTURE YOURSELF (OR YOUR SUBJECT) WORKING ON A PROJECT.** Use your self-timer (see page 138) or have a friend snap a photo of your hands as you knit, or of you hitting a tennis ball. Having photos that involve action gives life and energy to your albums.

❉ **THROW A HOBBY-RELATED PARTY AND CAPTURE THE EVENT.** Host a craft night and get photos of you and your besties finishing an art journaling project. If your hobby is more solitary, take photos of yourself with your projects through the seasons. For example, maybe it took you an entire year to finish your first quilt. Wouldn't it be awesome if you had a photo of yourself with the quilt in the spring when it was just a few scraps of fabric, then photos through the seasons as it grew into a new family heirloom?

Elsie and our mother have always loved painting.

ACHIEVE A GOAL THROUGH PHOTOS

Checking items off your to-do list or finishing up a big goal is such a fantastic feeling! We love chronicling progress through photos. Looking back at these images reminds us of how far we've come and motivates us to keep pushing through to our goal.

Here are a few examples of how we have used photography to chronicle goals. Emma set herself a craft challenge to complete fifty-two projects in one year (that's one every week!). She has been photographing each finished project along the way, which helps motivate her to keep going. Elsie loves painting but hadn't made it a priority in her life for a few years, so she set herself a challenge to complete twenty mini paintings. She liked the mini size because it felt less intimidating. She photographed each one as she finished, keeping her on track.

challenge yourself!

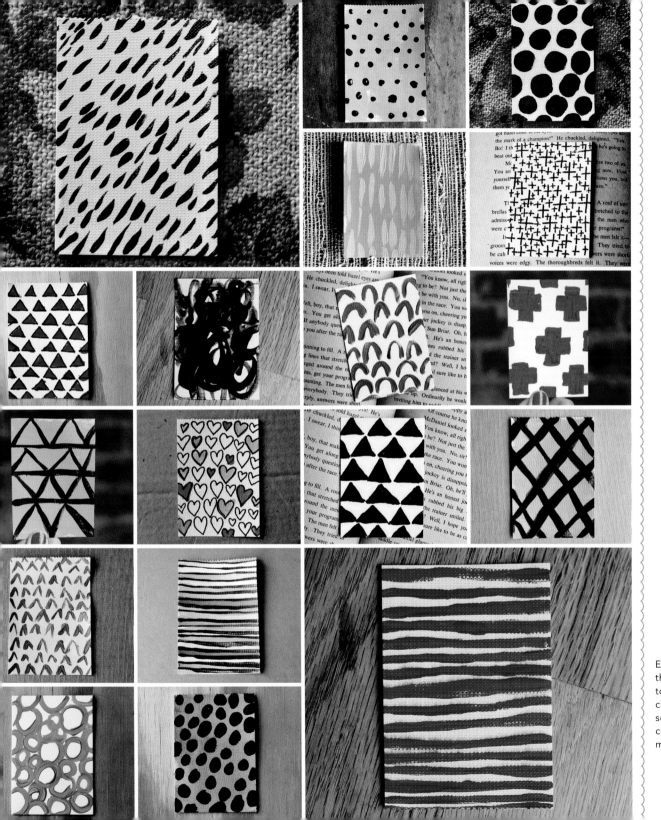

Elsie took these photos to document a challenge she set herself to complete twenty mini paintings.

PHOTOGRAPH FOOD

Sure, there are times when it's inappropriate to take photos of your food. And if you're not comfortable taking photos when you're at a restaurant with your family, that's totally cool. But we love photographing food, at home or out and about, because it's such a big part of our lives. Lots of dates revolve around eating out, and many of our favorite vacation memories involve treats or having that perfect sushi roll near the coast. We also adore how so many foods are seasonal and remind us of traditions throughout the year, such as pumpkin pie at Thanksgiving. Whether you are taking a quick food picture while on your honeymoon or setting up a photo of your grandma's apple pie at your kitchen counter, here are five tips for getting great food photos.

✳ **NATURAL LIGHT IS YOUR FRIEND.** Whenever possible, use natural light when photographing food because artificial light can give it an unappetizing shade. Photograph food during daylight hours, or move your cake closer to the window before taking a shot.

✳ **FOOD STYLING ISN'T JUST FOR FOOD STYLISTS.** If your photo looks a little dull, add a colorful napkin under your plate. If your image looks too cluttered, remove the silverware. You control what's in the frame, so take a moment to think about the whole image before snapping your photo.

✳ **TRY DIFFERENT ANGLES.** Food is a funny subject. It can be colorful, oozy, busy, tall or flat, circular or square. Because of this variety, it's best to photograph from all different angles to see what looks best. One of our favorite angles for food is from above. This often requires us to stand above our food—maybe even on a chair. (We don't recommend this if you're at a restaurant. Ha!)

✳ **FILL THE FRAME.** You want your photo to feel full and active. This doesn't mean you should get a super close-up of your mashed potatoes, as it's likely you won't be able to tell what it is. But as you compose your photo, think of filling the frame, edge to edge, with your subject.

✳ **POUR, SPRINKLE, AND TAKE A BITE!** Food is not a particularly active subject matter; it just sits there. One way to add life to your food photography is to capture a photo of you interacting with it. Pour a little maple syrup over your pancakes, or sprinkle cilantro onto your curry dish. It's also fun to take a photo after you've taken a bite. Plus, some foods reveal themselves as you eat (hello, cream-filled cupcakes!). Don't be afraid to get active.

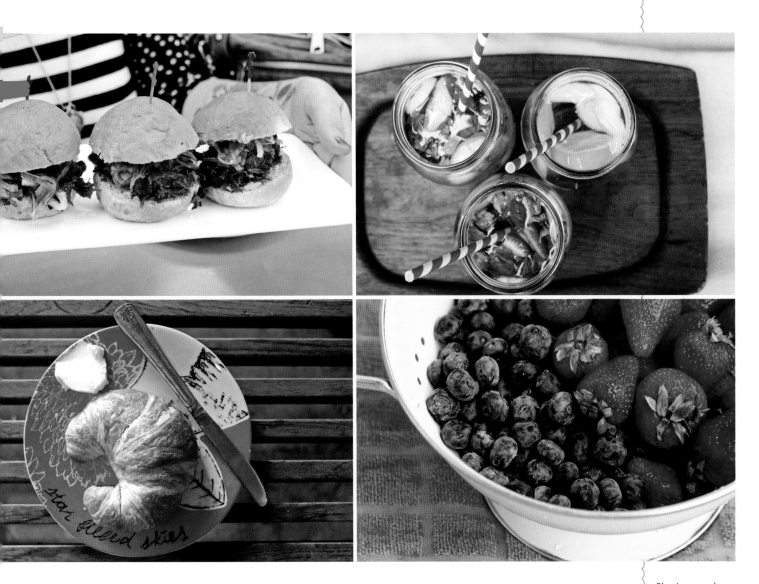

Sharing meals is such a big part of our lives. Why not capture them?

CAPTURE THE PLACES YOU GO

Our lives are very much tied to the places we go. We all grew up in a certain town (or two or three). Many of us move away for college. We may fall in love and move somewhere with our partner to start a family together. We take trips with our loved ones. Bottom line: we go places. So when you go, remember to take your camera. It's easy to remember to carry your camera while on vacation, but make a special point to take it on adventures around your hometown, too.

Sometimes we only take photos of things we think are amazing or completely different from what we are used to, but don't forget to snap photos of seemingly ordinary things, such as pretty store signs and fancy table settings. And never be afraid to photograph the everyday places in your life. Places have a way of changing over the years, something we learn more and more as we grow up. We love having photos from all of the important but seemingly mundane places that have been the settings of our lives.

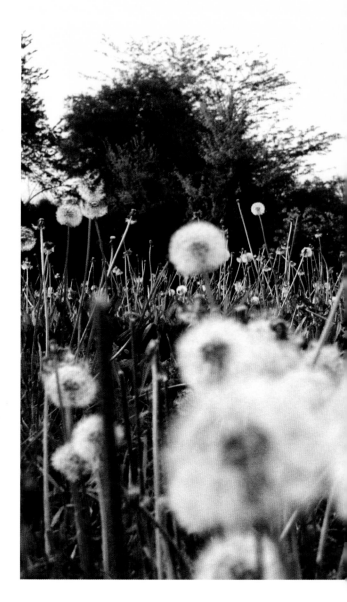

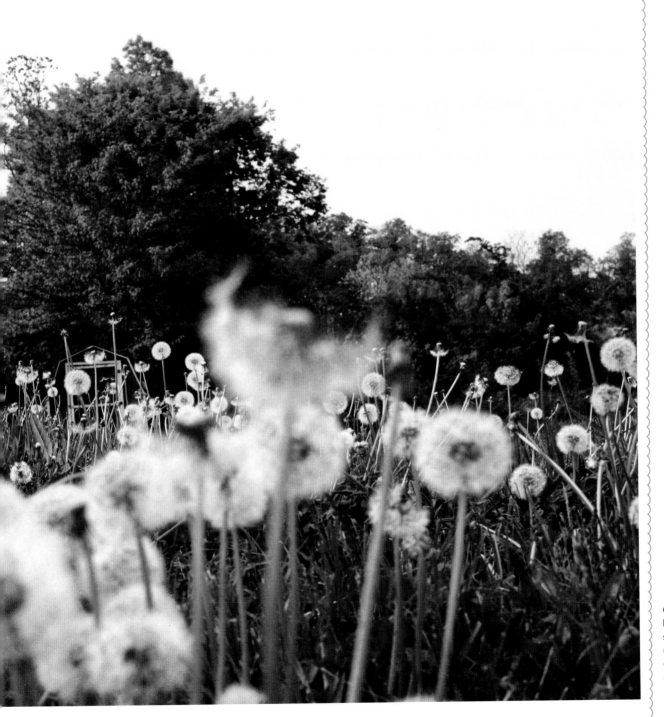

Our parents'
backyard, the
setting for so
many of our
childhood
adventures.

TAKE PHOTOS ON THE GO

We are often so busy rushing from one event to the next, it's easy to forget that life is made of all the little moments in between! Why not get photos in the car, on the plane, on a train, riding your bike, or on any part of your daily journey?

Some ideas for capturing photos on the go include photos of you and your mister on the plane headed to your honeymoon, photos of your commute to your first real job, even photos of your daughter climbing onto the school bus for her first day of school. (Oh, and yes, we are encouraging you to take photos of your life on the go. But we also gently remind you not to take photos while actually driving or during any activity that needs your full attention. Our lawyers made us say this, but it's probably a pretty good idea anyway.)

Commutes can be pretty! Don't forget to snap photos of the little moments that make up your life.

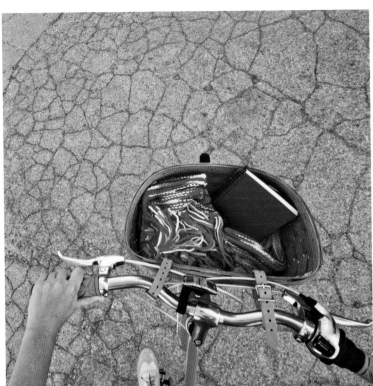

riding my bike

Emma snaps a quick photo while riding her bike.

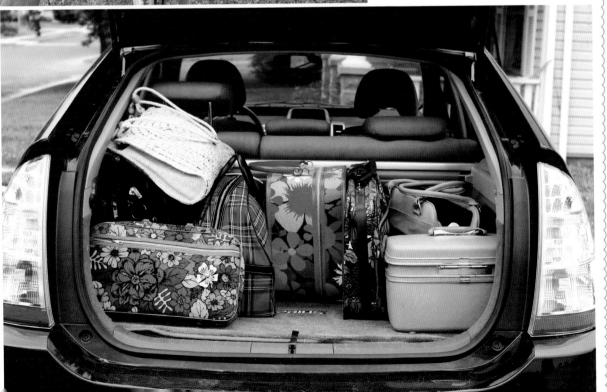

Elsie's and Jeremy's luggage before their honeymoon.

PHOTOGRAPH YOUR CURRENT OBSESSION

Photographing your current obsession, whether music or shoes, is a way to capture your changing interests over the years.

Don't think you have a current obsession? Come on now, dig deep. We all have little activities and rituals that we get into for a season. It's so much fun to watch our little two-year-old niece start to have obsessions. She has favorite toys and games and things she prefers to eat (Popsicles!). As we age, our obsessions mature with us; instead of Popsicles, we might get into French-press coffee. Here are three tips for photographing a current obsession, no matter what it is.

✳ **CAPTURE YOUR SUBJECT IN ACTION.** Get a shot of your niece enjoying her Popsicle or a photo of your husband meticulously measuring his coffee beans for that perfect morning cup.

✳ **GET THE MOST AWESOME LIGHT YOU CAN.** This may mean stepping outside for a quick photo of your current hobby.

✳ **TRY NOT TO OVERCROWD YOUR PHOTO.** Keep it simple. The goal is to get a pretty photo that reminds you of this window of time; it doesn't need to be complicated or overly artistic.

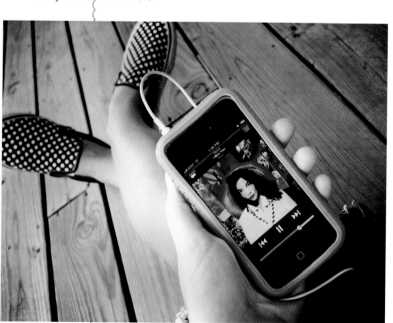

Elsie loves creating flower arrangements. We snapped most of these photos on her front porch because the light was so much better than indoors.

PHOTOGRAPH MUSIC

We have such emotional connections to music. Emma has a habit of listening to the same album over and over again for months at a time, which attaches that music to certain eras of her life. For example, she always remembers moving back to the Midwest from California when she hears Arcade Fire's *The Suburbs* album. Music makes up the soundtrack of our lives, so it can be fun to remember playlists through our photos. This can include pictures of records, adding a lyric to our photos or our albums, or just capturing the atmosphere at a concert we loved.

Elsie and Jeremy have matching headphones.

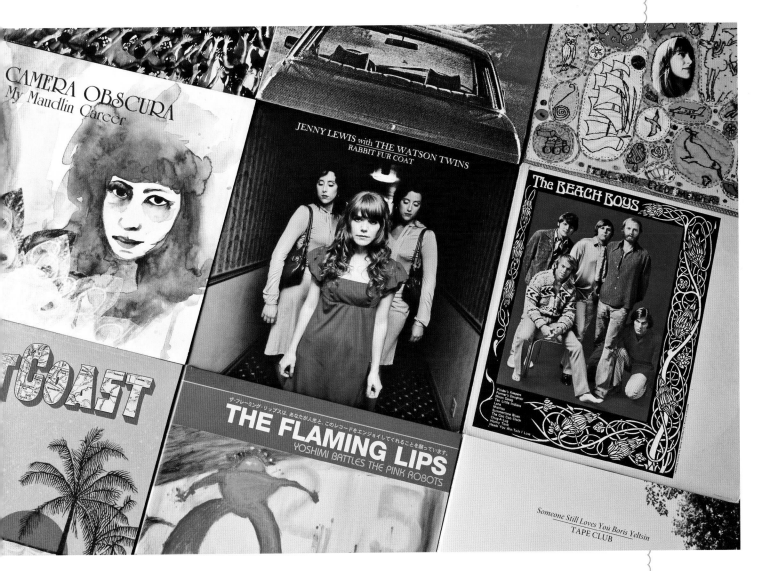

These records are not normally laid out this way, but we posed them so we could snap a photo of Elsie and Jeremy's record collection.

6

Capture Yourself

They say practice makes perfect, but when you are starting to explore the world through your camera, you may not want to involve others until you feel more confident in your skills. Taking pictures of yourself is a great place to start. You can experiment freely without worrying what anyone else will think—plus, you never know what you will get. Some of our favorite pictures of ourselves were taken when we were bored and exploring with our cameras. And in today's world, where we use self-portraits on everything from Facebook to our blog, who doesn't need a constant portfolio of great pics? Here are some tips for getting flattering, eye-catching self-portraits with whatever camera you have on hand, even an iPhone.

PHOTOGRAPH YOUR REFLECTION

One of our favorite ways to take a self-portrait is by using a reflected surface, such as a mirror. Simply face the mirror, look through your camera lens, focus, then move the camera away from your face (but still pointed toward your reflection) and snap away! If you are using a digital camera, you can take as many pictures as you want, so don't worry if your first few are blurry or miss their target. Here are some tips for taking the best reflective portraits:

✳ **LOOK INTO THE LENS.** We all have a natural inclination to look at ourselves in a mirror. But when photographing yourself in a reflective surface, you want to look into the *lens*, rather than at yourself, before you snap the photo. Though of course, if you want to look to the side or down for variety, that's fine, too!

✳ **HOLD YOUR CAMERA AT DIFFERENT ANGLES.** Try holding your camera low and high for different looks. Everyone's features are unique, so try photographing yourself from interesting angles to see what you prefer. You can also hold the camera down low to "hide" the camera by cropping the image later to be just your shoulders and face. Just remember that the lower (or higher) you hold your camera, the more you will need to angle it so the lens is pointed at your face.

✳ **PAY ATTENTION TO YOUR SURROUNDINGS.** Check your lighting: is it too dark or too bright? You may find that images taken in your bathroom are blurry or unflattering—this means it's too dark. Add light by moving a lamp or other light into the room, or move to a different spot. Try a mirror near a window in your bedroom and see if that's better.

Another thing to check is your background. What color are the walls around you? Are there towels hanging behind you? Attention to details like this will help your photos look more polished.

✳ **TRY LOOKING IN DIFFERENT DIRECTIONS.** You may find that you love your profile, or that you prefer looking straight at the lens to highlight your eyes. Try tilting your head one way or the other to add interest.

✳ **TAKE A DEEP BREATH.** It's easy to move or shake slightly when taking a picture, especially if you are holding the camera at an odd angle. To avoid this, get yourself in position, set up your picture, then breathe deeply and exhale before you take the photo. This is the best trick we have learned to steady the camera.

And remember, mirrors aren't the only reflective surface out there! Try large glass windows (such as shop windows), rain puddles, or a swimming pool.

Now you see
the camera,
now you don't!
Try holding the
camera down a
bit so you can
crop it out of
the final image.

*hide
your
camera* ↘

HOLD THE CAMERA AT ARM'S LENGTH

Experiment with looking at the lens, versus away. Hard to believe these are arm's-length self-portraits, right?

Another technique for taking pictures of yourself, or yourself and a friend, is to hold the camera at arm's length. To do this, simply hold your camera far enough away to get everything you want in the frame and then snap a photo. This can be challenging because you won't be able to see what you are photographing. A lot of trial and error may be necessary, especially at first.

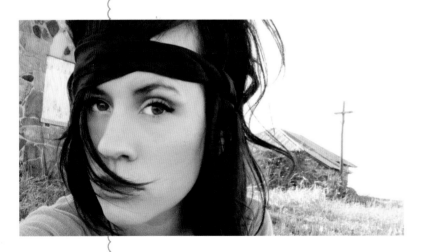

There are times to use your on-camera flash, but photographing this close to your face is not one of them! Turn off your flash or you will end up with blown-out photos and maybe even compromised vision. Since you won't be using your flash, you need good lighting. A great option is to sit or stand directly facing a window; window light is very flattering.

As you explore different angles, holding your camera down low or up high, watch out for unflattering details that arise. For example, if your arm is in the frame, it may look distorted when you hold the camera up high. When you hold the camera low, you may need to adjust your head position so your chin and neck don't look distorted.

This technique is also useful when you are out with a friend and you want to get a picture together. Elsie takes a picture of us like this with her iPhone almost every week! When photographing two subjects, focus on only one person at a time to avoid a blurry photo. Most cameras have a hard time splitting focus, so slightly angle the lens toward one person when snapping the photo.

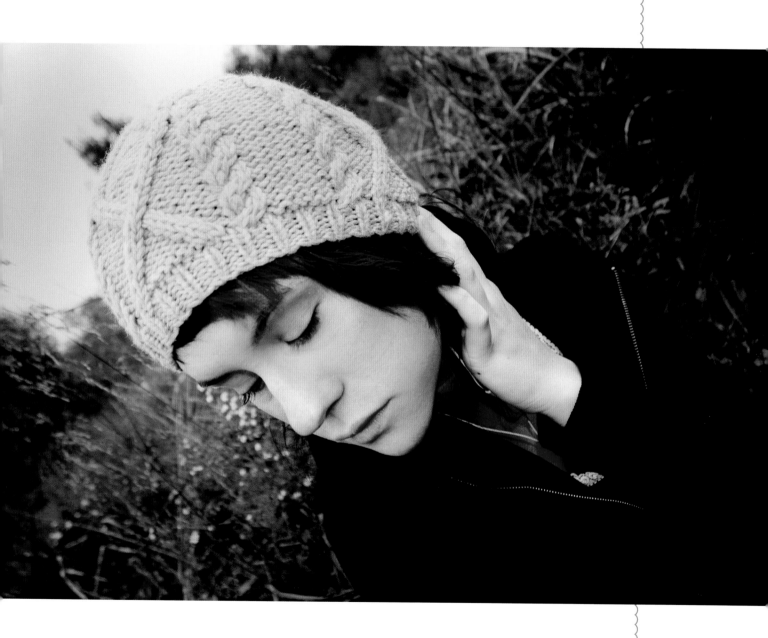

USE A SELF-TIMER OR CAMERA REMOTE

ost digital cameras have a built-in self-timer—you just push a button and after ten or so seconds, your camera will trip the shutter automatically. If you're using an iPhone, there are self-timer apps you can easily download. Another option is a *camera remote*, which you can use to snap a photo without touching the camera. Either way, here's how to do it.

If you don't have a tripod, set your camera on any stable, flat surface.

oops...blurry

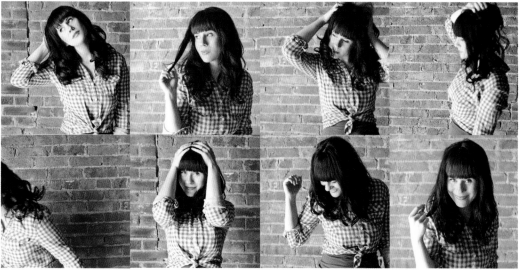

outside of frame

favorites!

Give yourself lots of options and don't worry about every image being picture-perfect.

✳ **SET UP YOUR CAMERA.** Find a solid surface to balance your camera on. The most common (and easiest) option is a tripod. Tripods are inexpensive and can be attached to most cameras. You can adjust them to hold the camera higher or lower, and you can adjust the legs to stand on a sloped surface. Most tripods are lightweight and easy to tote around. Just remember to weigh your tripod down if it's windy by hanging a heavy object (such as your camera bag or purse) from the center post.

If you don't feel ready to invest in a tripod, you can use almost any flat surface, such as a countertop, table, or chair. Just remember to choose a surface that is level and secure; you don't want your camera falling off and potentially breaking.

✳ **SET UP YOUR SHOT.** Think about the composition of your picture. Where will you want to stand? What do you want the camera to focus on? If you simply focus your camera on anything and then move yourself into the frame, your photos will probably turn out blurry, as the camera will focus on the background. A helpful tip is to use something—a friend or an object—to stand in for you while you set up the shot. Put the stand-in wherever you want to be and focus on it. When you activate the self-timer, move into that exact same spot. (Or if you're using a remote, stand in the spot first and then trip the shutter.)

Don't expect to get a perfect picture the first time you use your self-timer or camera remote (or even the tenth!). Give yourself time to experiment and make mistakes. And don't forget to have fun!

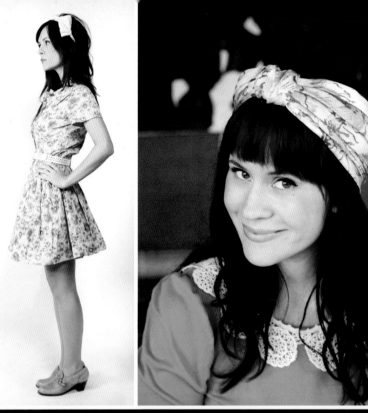

Self-portraits don't have to be traditional headshots. Experiment and have fun!

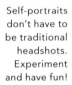

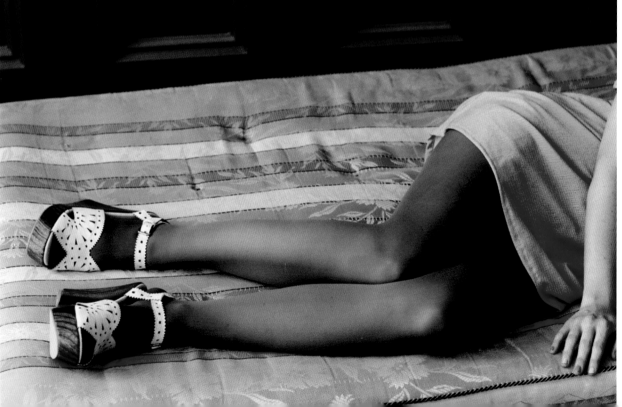

OUR FAVORITE MAKEUP AND STYLING TIPS

nstead of looking same old, same old in your photos, why not try something new? Here are our favorite ways to use makeup and accessories for more interesting, eye-catching self-portraits.

✳ **GO RETRO.** There are so many pretty makeup and styling trends from the 1950s, 1960s, and 1970s. Try doing your makeup like a style icon, such as Twiggy. These looks may be too extreme for an average day, but this is just something fun for a picture.

✳ **ACCESSORIZE WITH A PURPOSE.** Accessories are a great way to add pops of color or texture to your photos. But before you pile on the baubles, think about the big picture. What kind of look are you trying to achieve? The best way to avoid looking too "busy" is to accessorize with a purpose in mind. A good rule of thumb is to highlight one area, such as your hair or your hands.

✳ **WEAR SOMETHING MEANINGFUL.** We love including items that were handed down to us, whether swimsuits from our grandmother's honeymoon or our mother's letterman jacket from high school. Why not incorporate items such as these into more casual outfits and photos?

✳ **HIGHLIGHT YOUR FAVORITE FEATURE.** Use different colors or makeup techniques to highlight your favorite feature. Emma's favorite feature is her hair; she wears it down most days because she likes the color. Highlight something that fits your personality.

✳ **GO NATURAL.** Don't shy away from snapping a picture of yourself even if you still have bed hair. Sometimes less is more, and these kinds of images can show the beautiful and vulnerable side of yourself.

Clockwise from top left: Elsie showing off a cat-eye eyeliner look; Emma trying a Twiggy-inspired look; Elsie incorporating our mother's high school cheerleading jacket; Emma highlighting her favorite feature: her hair.

OUR FAVORITE WARDROBE TIPS

The colors, style, and cut of your clothes have a huge impact on how you look in your photos. Plus, getting a little *dressed up* can help you feel more confident. Here are some tips for choosing a knockout outfit.

※ **WEAR SOMETHING WITH CONTRAST.** Bold patterns and contrasting colors can add interest to a photo. One of our favorite tricks is to wear all black and white. There is something about the contrast between them that really makes a photo pop.

※ **KNOW YOUR COLORS.** Every skin and hair tone has a range of colors that complement it best. For example, redheads tend to look stunning in jewel tones. Experiment and see what colors look best on you.

※ **KNOW YOUR BODY TYPE.** Our differences are what make us beautiful, so don't be afraid to honestly consider what body type you have. Once you've identified your shape, look to vintage icons or celebrities with similar shapes and see what they wear and how they style themselves. You can take advantage of their stylist's tips without spending a penny! If you love your hands, paint those nails and show them off! If you have adorable shoulders, invest in a strapless dress. We should all celebrate the things that make us beautiful and unique!

Elsie feels best in knee-length dresses with heels, while Emma prefers outfits with a fitted waistline.

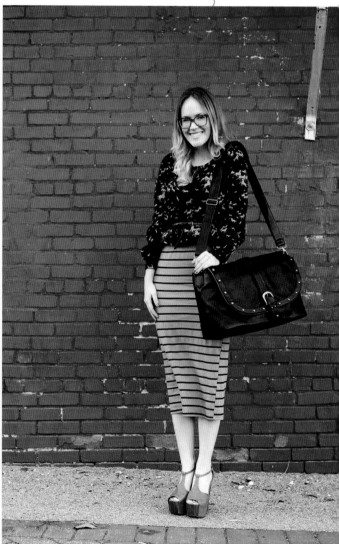

OUR FAVORITE HAIRSTYLING TIPS

Are you so afraid of trying something new that your hair looks the same in every photo—and has since you were six years old? Here are a few ideas to shake you out of your hairstyling rut.

✳ **WEAR BRAIDS.** Braids can add texture and dramatically change your hair length without actually altering your hair. They can look polished or bohemian, depending how you style them. That's the mark of a classic trend.

✳ **ADD A FANCY HAT.** Hats add color and show off your personality. Add a retro mini veil for a bridal or dressed-up look, a fedora for a casual and cool look, or a sun hat for a vacation feel. No matter what length your hair is, you can always dress up your look with a cute hat!

✳ **TRY A RETRO HAIRSTYLE.** There are great resources online to help you do retro styling. Why not take the time to create a beehive look? It's not something you'll do every day, but it adds a vintage feel to portraits.

✳ **ACCESSORIZE.** Try adding pieces of lace or decorative hairpins for a different look. Remember, it doesn't have to be something that you would wear in real life.

Braided hair adds interest and texture to a picture.

maiden braids

← *beehive!*

Left, top: Try
retro hairstyles
to change up
your look.

Left, bottom:
Don't forget
to capture
the details of
your changing
hairstyles over
the years.

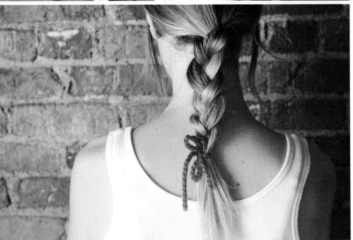

Above: Emma's
pretty yellow
scarf adds color
to her portrait.

TAKE THE THIRTY-DAY SELF-PORTRAIT CHALLENGE

A few years ago, a friend encouraged Elsie to join the 365 challenge on flickr.com. The idea was to take a self-portrait every day for a year. According to the rules, you had to be in the photo in some way and you had to take the photo yourself. As the weeks went by, Elsie started getting more and more creative, experimenting with reflective surfaces, lighting, and styling. What started off as a just-for-fun challenge turned into an incredibly rewarding creative project. She was able to move past just capturing a pretty photo and learned how to capture her everyday life.

We want to give you the opportunity to have the same kind of experience! Here's our modified (meaning *shorter*) version of the challenge, should you choose to accept it:

- Take thirty days of self-portraits (one every day for a whole month).
- The portraits have to be about you or show you in some way.
- You must take the pictures yourself.
- As you go, share your photos with a close friend, with your spouse, or online via Facebook or your blog.

The results of
Elsie's thirty-day
self-portrait
challenge.

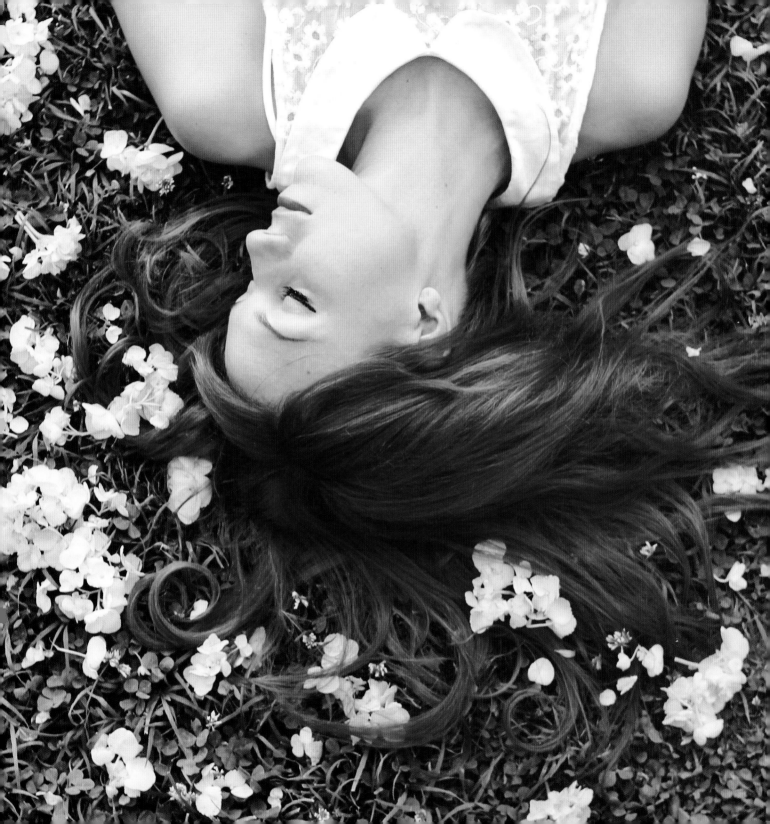

7

Challenge Yourself

As with any hobby or practice in our lives, it's easy to let your photography fall . . . well . . . into a bit of rut. It happens. Don't get discouraged! Over the years we've tried different things to push our creativity during these moments. This chapter is all about challenging yourself and stretching your skills as a lifestyle photographer. Pick a challenge or tip that interests you and go for it!

CREATE A DIPTYCH

Diptychs are pairs of images displayed together. That's it—simple! In fact, it's so simple you may be thinking, "What's the big deal?" And you're totally right. But think of diptychs as a cocktail of photos: simple ingredients that when paired together create something more interesting and flavorful.

Pairing images can add a lot of strength to the overall design. Choose images that complement each other in some way, images that when put together make you think. Sometimes when you display images together they become more artistic or tell more of a story than when viewed on their own.

You can create diptychs in all sorts of ways. You can use photo-editing software to digitally pair your images. You can get an iPhone app that does it for you. Or you can create them the old-fashioned way, using nothing more than scissors and glue. Whatever your method, pair photos that complete each other and add more interest to your display.

pair a photo of yourself with a favorite interest →

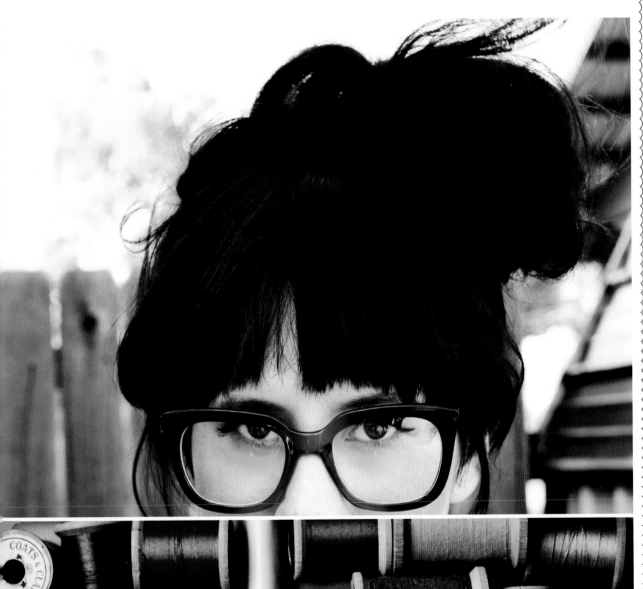

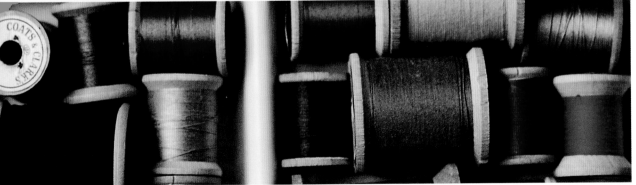

A diptych
is a pair of
images
displayed
together.

CREATE A TRIPTYCH OR POLYPTYCH

The same idea behind a diptych (page 152) can be used to create a triptych (three images displayed together) or a polyptych (more than three images). Just use the same methods you would for traditional diptychs. As with diptychs, these help images become stronger by combining them with other photos in an artistic way. With three or more images, you can be more literal or tell a longer story, almost like a short comic strip.

Here are a few simple rules of thumb when choosing your images.

✳ **CHECK THE COLORS.** Make sure all colors complement each other. Your images don't have to "match," but the viewer's eye should smoothly travel from one image to the next.

✳ **VARY THE LEVEL OF DETAIL.** Keep some images simple and others more detailed. If you use all detailed images, it will force your viewer to recognize each image as separate instead of part of a whole. You want your final collection to feel fluid, rather than made up of separate components.

✳ **COMMUNICATE ONLY ONE SIMPLE IDEA.** You could create a triptych showing three details of your outfit. Or you could use two images of raw ingredients and then an image of the final baked product. Whatever the case, keep the idea simple.

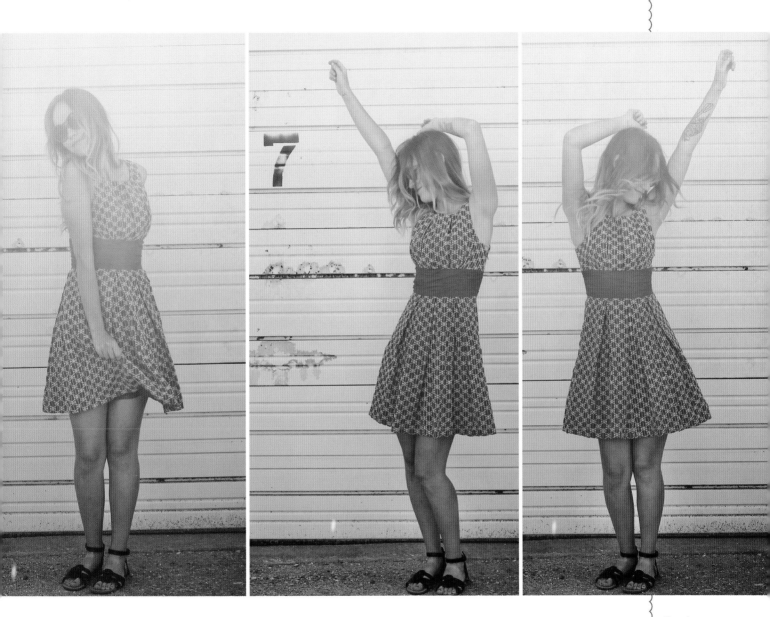

Use three or
more images to
tell a short story.

TAKE A PHOTO FROM ABOVE

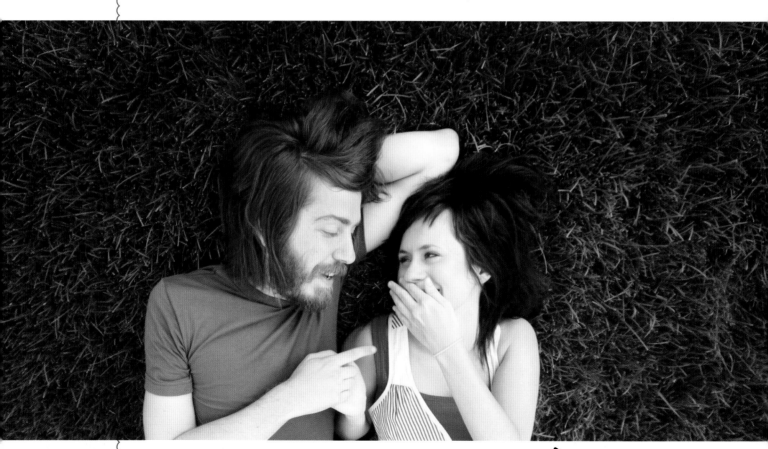

try something playful!

This concept is super basic: find a way to get above your subject. This could mean using a stepladder, a chair, a picnic table, a stairwell, a ledge, levitation (okay, maybe not levitation), or any raised area. Don't be afraid to think outside the box when trying out different angles or levels to photograph from. And as always, be safe.

Before you climb into position, be sure to arrange your subject, whether arranging food on a plate or draping your subject's hair around her head. Also, pay close attention to how the light is falling on your subject. This angle may be quite different from what you are used to, so check for any harsh or unwanted shadows.

Opposite: A photo taken from above can have a whimsical feel because it's a view we do not usually get to see.

CREATE AN UPSIDE-DOWN PHOTO

Turning images upside down forces us to look at them in a whole new way. Once your subject is in a position you don't normally see it in, your eye can evaluate it and see different aspects than before. For example, you will easily be able to see how balanced a photo is by flipping it. Not every photo needs to have symmetry, but balance helps us get acclimated to an image. It invites us in. If you find yourself ho-humming at your photos, flip them upside down and see what you think! Not every photo will benefit from this treatment, but the exercise can stretch us to view our photos in a new way.

To flip your photos, use photo-editing software or simply rotate them by hand and display them in their new position. Try it with a few photos you already have and see what you think!

Our friend Katie is looking just gorgeous in this upside-down (and from above) photo!

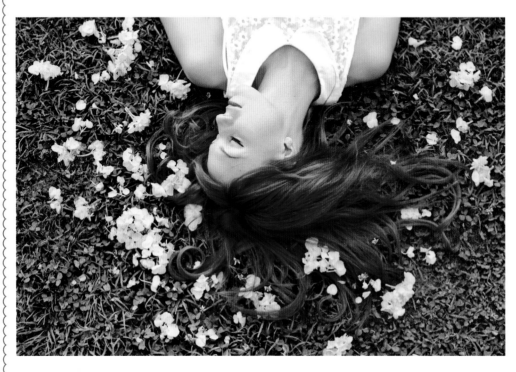

Using upside-
down photos
every now and
again can add a
lot of variety to
your work.

WEAR A COSTUME

Costumes aren't just for kids! When you think of costumes, you probably start thinking about Halloween or getting dressed up for a school play. Those can be fun for a photo, especially with kids. But costumes can also be simple, stylish, and super inexpensive. For example, making a mask from painted cardboard or even just wearing a formal vintage dress can be a fun change.

Remember to keep it simple. Use only a few colors to avoid looking too busy or dressed up. Costumes may feel a tiny bit silly, but they can truly add an otherworldly element to your next photo shoot.

Adding a wig will totally change the look of your subject and possibly inspire him or her to feel like a different person.

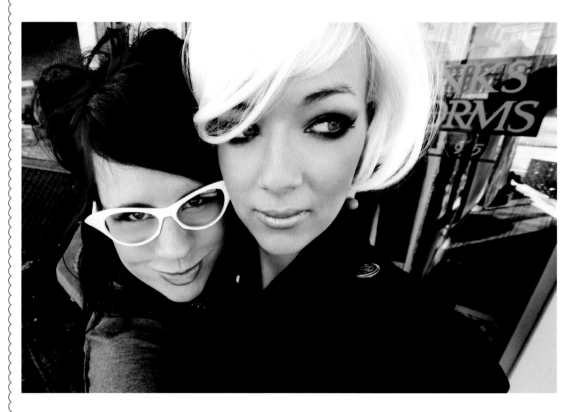

This pipe cleaner
crown took
only minutes to
make but adds
magic to Stacy's
portrait.

RE-CREATE AN OLD PHOTO

f you love looking through old family albums, you probably already have favorite old photos of family members or friends. Having this point of inspiration can give your next shoot a whole new level of focus. Here are two ways to re-create an old photo.

✳ **GIVE AN OLD SUBJECT A NEW SPIN.** Find an old photo and try to duplicate the look and feel of the photo with a new subject. We used Elsie to re-create an image of our grandmother. They are two peas in a pod, so it's fun to have these photos to display together.

✳ **USE THE SAME SUBJECT YEARS LATER.** Why not re-create one of your parents' wedding photos on their thirtieth wedding anniversary? You don't have to be in the same location or have them wearing the same clothes; just try to mimic the look and feel of the original photo.

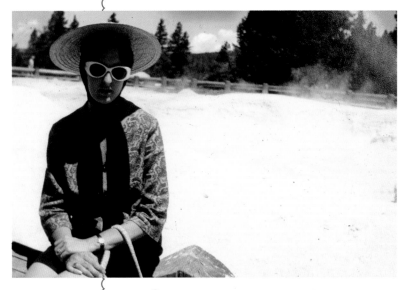

our grandmother is so stylish ♡

Our grandmother, Corina, is our style icon, and she and Elsie have many similar personality traits. We love re-creating old photos of her.

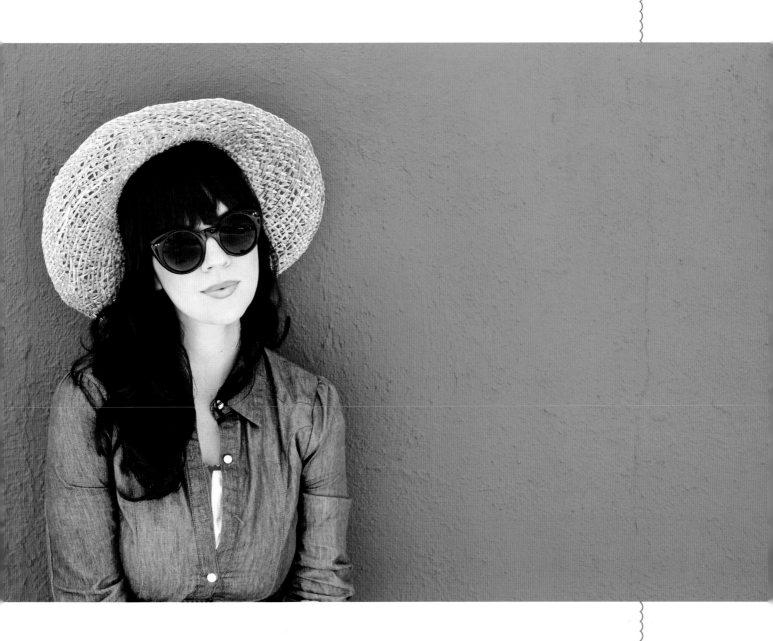

HAVE FUN WITH COLOR

Challenge yourself to have fun with color! Look around your home, neighborhood, and city to find colorful walls. Look through your closet for colorful outfits. You can even consider creating your own colorful backdrops (see pages 36 to 43).

Once you find color, get creative with using it. Remember, you can choose what colors make it into your photos and which do not. Normally, it's best to use colors that you are naturally drawn to or that complement each other. But for this challenge, feel free to break the rules! Don't be afraid to use colors that clash or to mix multiple colors together. Every photo may not be perfect, but it's good to stretch yourself creatively and try new things.

Vivid colors add life and energy to your pictures. Look for pretty colors as you photograph your world!

Overleaf: Photographing color can be as easy as capturing the pattern on your bright dress, or snapping a picture of citrus slices as you prepare cocktails for friends.

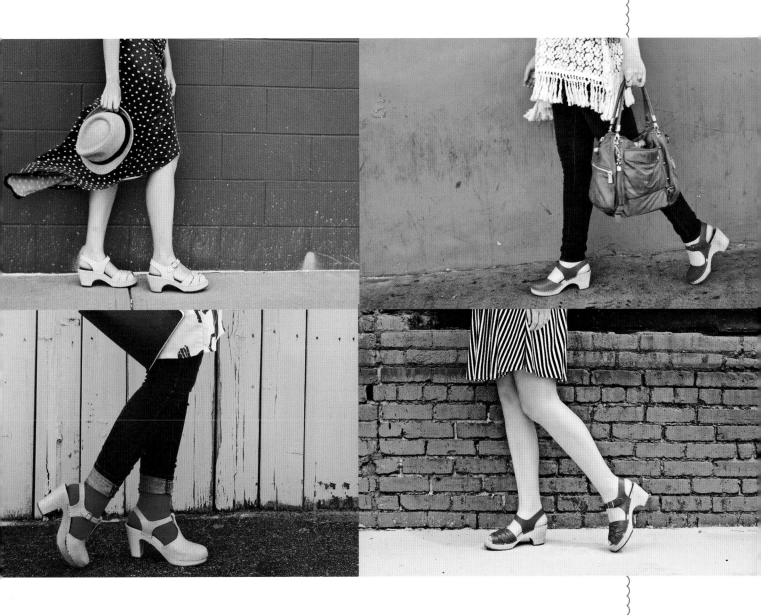

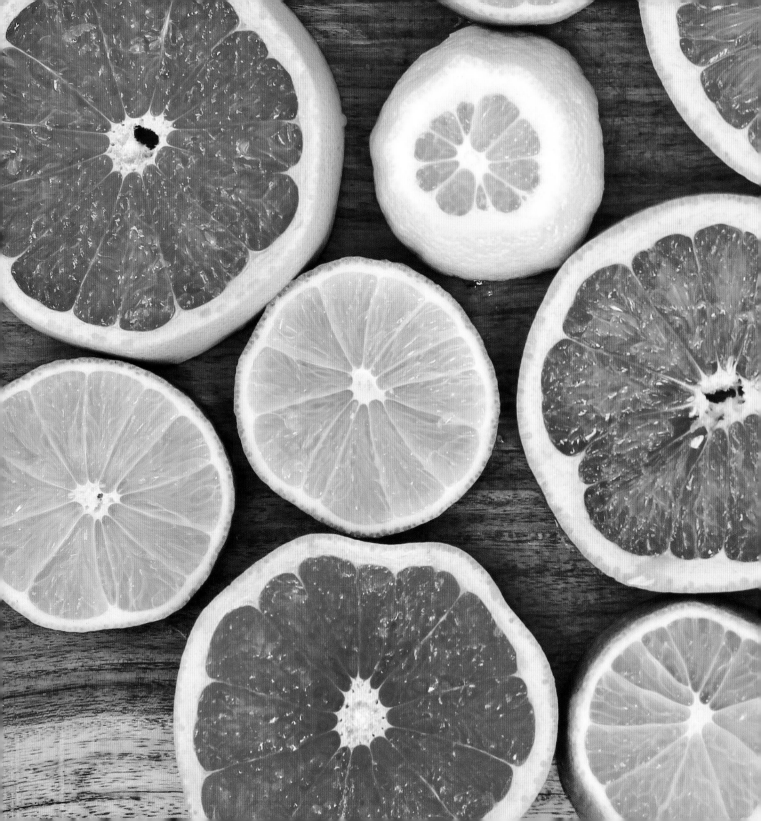

CHOOSE AN INSPIRATION ICON

This challenge is similar to our costume challenge in that the purpose is to try something new, something you would not normally do. We all have styles we are comfortable with, but for this challenge, take a cue from your favorite style icon!

You can make this as extreme as you like. Choose a current or past style icon—a model, actress, rock star, whatever—and model your or your subject's look after that person's. It doesn't have to feel like a costume! Use your icon's makeup technique or hairstyle to spice up your photos.

Stacy channels the 1960s darling Twiggy.

Twiggy inspired!

Try something
glam-rock
inspired!

TAKE THE BLACK-AND-WHITE PHOTO CHALLENGE

When we first started taking photos, we were still using film cameras. At that time, black-and-white photos were extremely popular and often looked even better than color. We still enjoy black-and-white photos but often forget to use them, as we just love how colorful digitally processed photos can be.

Taking black-and-white photos strips away the distraction of color and allows you to focus on the negative and positive spaces in your photos. Composing your photos with the negative and positive spaces in mind—in other words, thinking about the spaces between subjects and how subjects are placed in the frame—can create a lot more tension. Tension is a different and artistic way to add interest to your images, as well as fill them with emotions such as urgency, peacefulness, and intimacy.

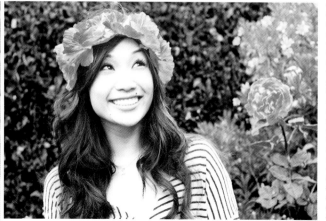

Change the
feeling of a
photo simply by
making it black
and white.

HAVE FUN WITH OUTTAKES

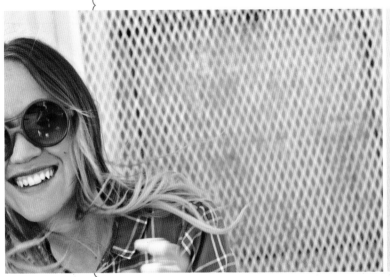

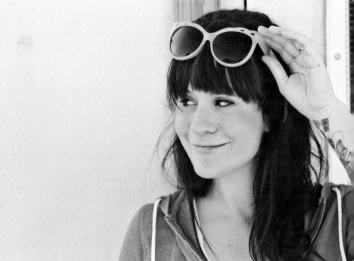

This is a lesson in allowing yourself to make and enjoy "mistakes." One of the best outcomes from taking extra photos during any shoot are all the mistakes, called *outtakes*. These photos can be fun and interesting, capture genuine emotion, and add a lot of life to your photo collection.

This challenge is a little different because it's not about taking photos, really, but about examining our finished photos. Usually we look for those few perfect images where the light hits our subject just so and everything looks in place. But sometimes it's the little *off* details that make a photo fun. Maybe your dad made a silly face during a family portrait session or your hair blew in your face—these are the unexpected and fun photos that happen with outtakes. Examine your next shot and look for beauty in the mistakes.

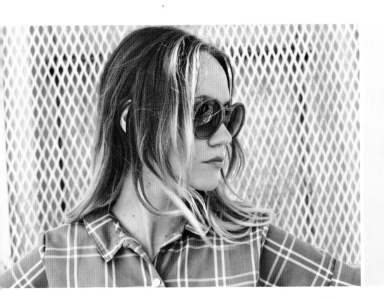
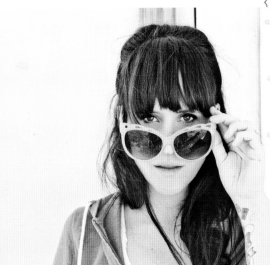

*sometimes outtakes
are beautiful, too*

Always review
the outtakes
from your
photo shoots;
you may be
surprised to find
a few interesting,
though not-
what-you-where-
going-for, photos.

FOCUS ON SOMETHING UNEXPECTED

We control the focus of our photos through our framing, cropping, and formatting choices. Usually there is a clear and expected focal point: a face, a flower, and so on. But sometimes it can be fun to focus on something unexpected. This can be a way to challenge yourself to see and notice new things. Find the beauty in *not* taking the obvious photo.

Here is how to practice this technique. First, take a photo. Now look at your image and notice the things around your subject (such as a coffee mug sitting on the table in front of her). Take another photo focusing on this new focal point. Try to find a flattering way to show off this object, instead of your original subject. You may be surprised at how this change in focus adds variety and interest to your shoot. These unexpected-focus photos may not be the highlight of your albums, but they will help create a fuller picture of your beautiful life.

By focusing on the treat, rather than the dog, we gave this photo an unexpected twist.

Instead of
focusing on
your subject's
face, focus on
something
unexpected,
such as these
coffee mugs.

HAVE FUN WITH PAINT

Here is another way to add something unique to your photos: add a painted element. You can paint on skin or inexpensive clothing. If you are working with kids, it can be fun to go crazy with paint, maybe even letting them choose the design or do some painting themselves. When working with adults, keep your concept simple. In this photo of our beautiful friend Sarah (opposite), we added a painted-on scalloped edge to the top of her dress, mimicking a fashion trend.

You can also use Silly String to mimic the effect of paint, as we did in this photo. Ask a friend to help, so one of you can spray the string while the other takes the photo.

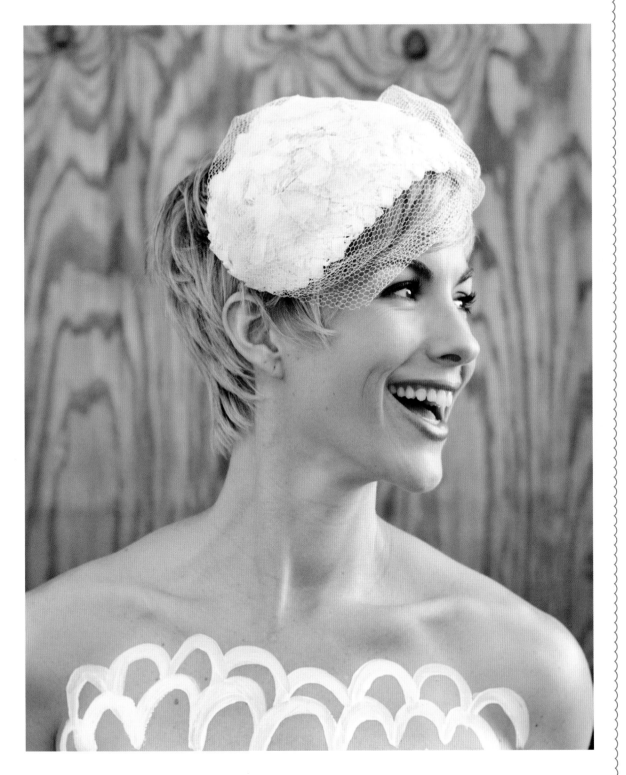

This photo makes the viewer do a double take as you try to figure out if the scallops are a dress or a painted-on feature.

TAKE PHOTOS IN PUBLIC PLACES

Have you ever been too afraid or embarrassed to get the photo you wanted? It can be a little intimidating to take photos in public. Here are our top three tips for taking photos in public.

✳ **WHEN IN DOUBT, ASK.** In some situations and places, it's not clear whether taking photos is allowed. Most museums have signs letting patrons know if photography (especially flash photography) is allowed. If no sign is posted, it's best to just ask. We own a small vintage boutique and we have customers ask all the time if it's okay for them to take photos. It's a polite gesture, and once you've gotten permission, you'll feel much more comfortable snapping away.

✳ **WORK ON SUNDAY.** Sundays and holidays are great days to scout locations, take photos outdoors, and use pretty building walls. If a business is closed, it will be easier to pose by their wall without disrupting their place of business.

✳ **USE YOUR JUDGMENT.** If you're not comfortable, skip it. There's no point posing for your photo if you or your subject doesn't feel comfortable, as this feeling will probably show through your expression or body gestures.

don't be shy about taking photos in public! →

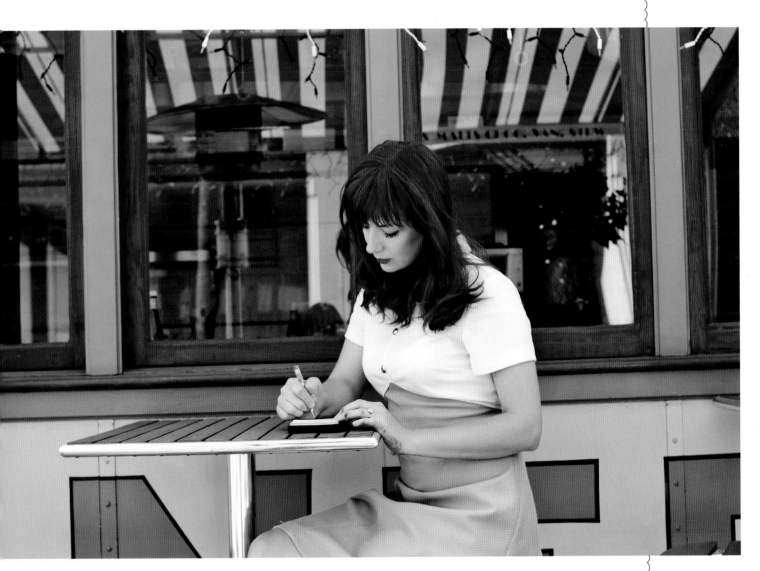

Taking photos in
public doesn't
have to be
intimidating.

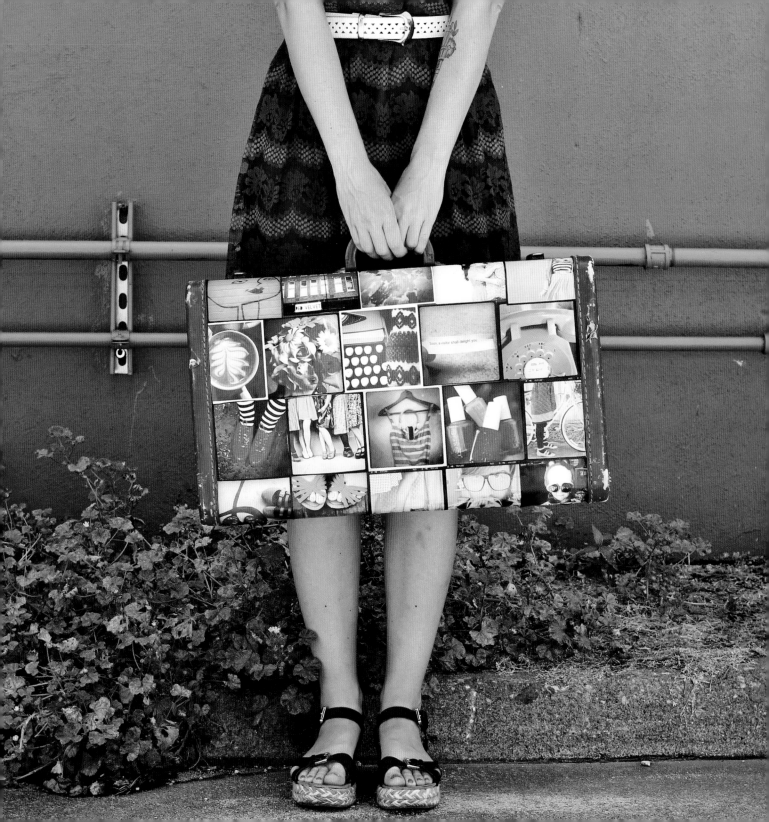

Show Off Your Photos

Taking pretty photos is all well and good, but what do you *do* with all those images? Saving them on a hard drive and posting the best to Facebook or your blog are good places to start, but don't let those be the only homes for your photos! There are so many creative options for using, displaying, and gifting your photo collection. Here are some easy and quick solutions for using your photos.

INVITES FOR EVERY OCCASION

Creating invitations from photos is super simple and adds the perfect personal touch to an event. Plus, using your own images ensures that your invites will be one-of-a-kind!

Supplies needed:

paper or cardstock, paint or pens, scissors

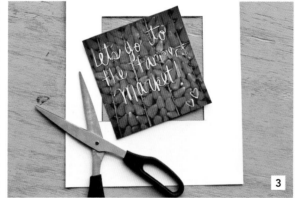

1. Print out photos you want to use on photo paper, cardstock, or copy paper. Use images that communicate something about the event, such as a cake for a birthday party.

2. Add text to the front using paint or pens, explaining the event. We used a white paint pen and then outlined the letters in black.

3. Cut out the cards.

4. Add event details to the back.

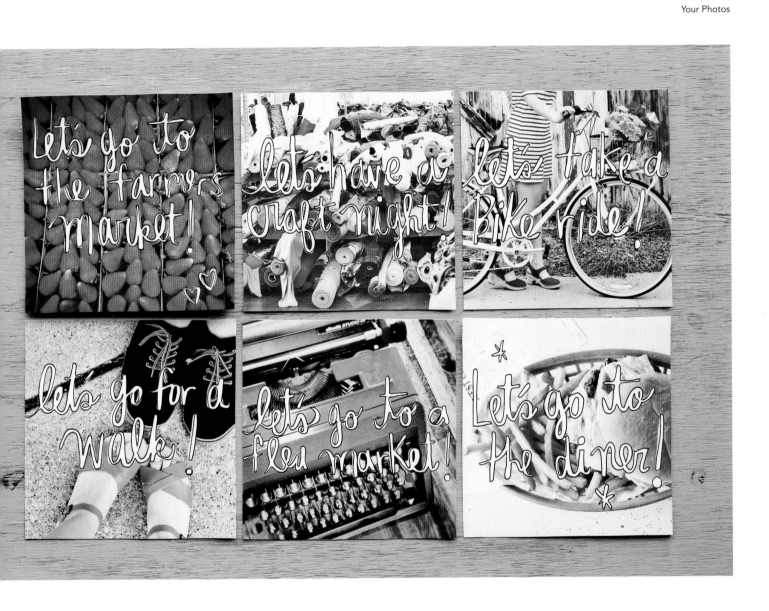

STORYBOOK LOCKET

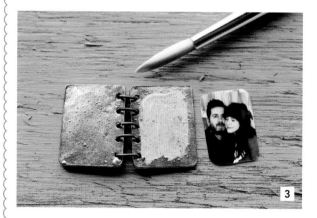

Photo lockets are a classic way to display and carry special photos of your mister, children, or pet with you throughout the day. But a locket doesn't have to only hold photos; you can also add tiny notes or messages inside.

Supplies needed:

ruler, locket, small photo, scissors, glue, paintbrush, extra charms

1. Measure the space for your photo on the locket and adjust your image on the computer as needed.

2. Print and cut out your small image.

3. Use a paintbrush to apply glue to the locket and carefully adhere the photo. Allow to dry (check your glue bottle for suggested drying times).

4. Add letters and/or charms to create a story or message that is meaningful to you!

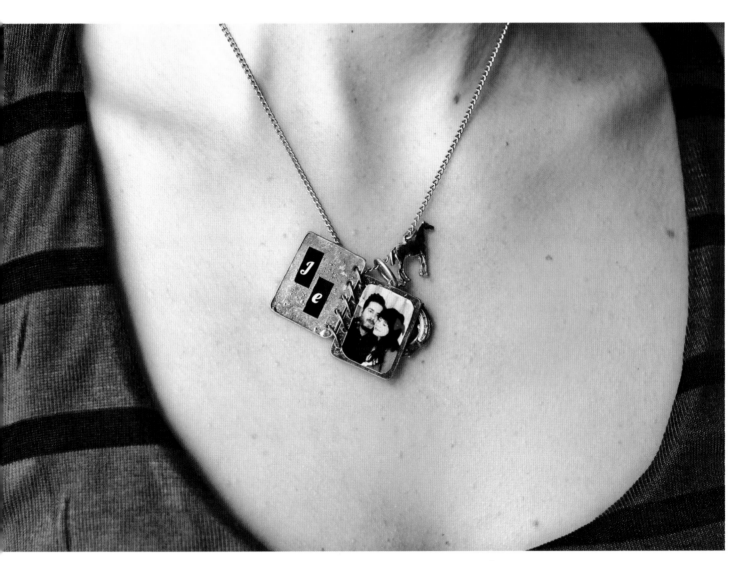

ʕawwww! ♡

PHOTO TRANSFER LAMPSHADE

Creating your own photo transfer lampshade is an excellent way to personalize your living space! You could use photos from a special trip or important event in your life. Remember that images will be backward after transfer, so avoid any images with words or letters in them.

Supplies needed:

measuring tape, cotton fabric (enough to cover the lampshade), scissors, photo transfer paper, iron (if needed), needle, thread, lampshade frame, fabric trim, fabric glue

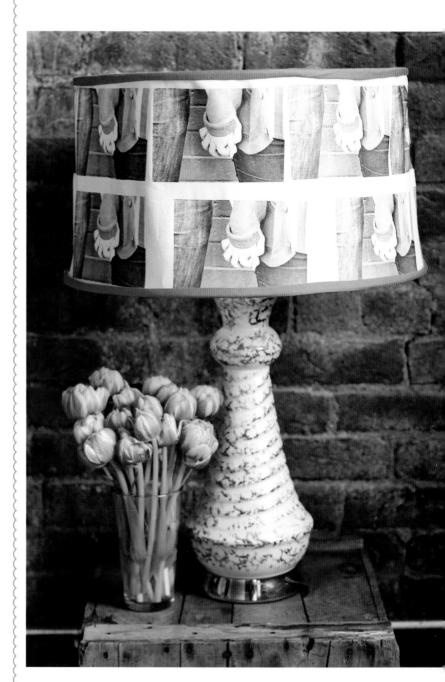

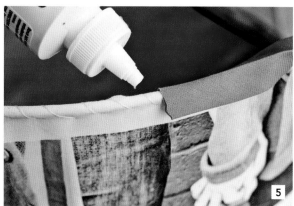

1. Measure the length and width of the lampshade frame. Add 2 inches to each side and cut out your cotton fabric.

2. Print your photos onto the photo transfer paper and cut out the images.

3. Follow the directions on the photo transfer paper to adhere the images to the cotton fabric. The brand we used required that we iron them on.

4. Use a needle and thread to hand-stitch your fabric to the lampshade frame.

5. Measure the circumference of the lampshade frame and cut your trim to fit. Use fabric glue to adhere the trim along the edge of the lampshade.

MEMORY MAGNETS

We love displaying special photos in areas of our homes where we can see them often. Here is a five-minute project to create magnets for your refrigerator. These are so simple and inexpensive to make. Don't be afraid to update your memory magnets as often as you like!

Supplies needed:

photos, self-adhesive magnet sheet, scissors

1. Print your photos. We printed ours on photo paper, but you can use plain copy paper if you prefer.

2. Peel back the paper on the magnet sheets and adhere your photos. Trim off the excess.

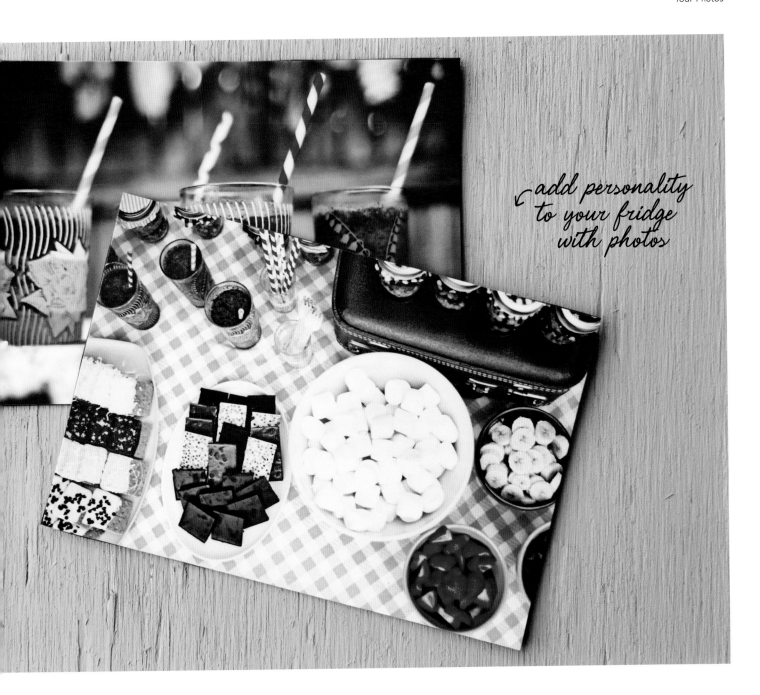

add personality
to your fridge
with photos

PHOTO PARTY DÉCOR

We love a good party! We love the décor, the desserts, and the party favors. We love it all! An easy way to personalize your next party is to use photos of your guests. Here are two easy and fun ideas. Customize these ideas for whatever kind of party you want to host, whether a small "welcome home" party for your husband as he returns home from a business trip or a baby shower for a friend.

PARTY BANNER

Supplies needed:

banner letters, photos, scissors

1. Choose the words you want to spell out.

2. Replace a few of the letters with photos, using the letters as a pattern to cut around your photos.

3. Add your photo letters to the banner.

PERSONALIZED CANDY BARS

Supplies needed:

candy bars, photos, scissors, tape, pens or markers

1. Remove the labels from the candy bars, but leave on the silver foil.

2. Print large photos onto copy paper and cut out.

3. Wrap a photo around each candy bar and secure with tape.

4. Use a pen or marker to write on the new wrapper if desired.

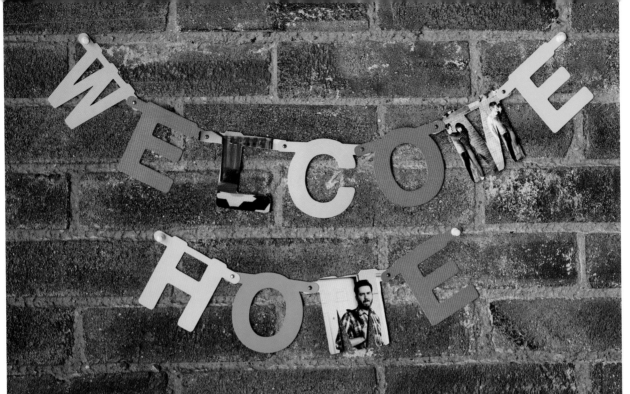

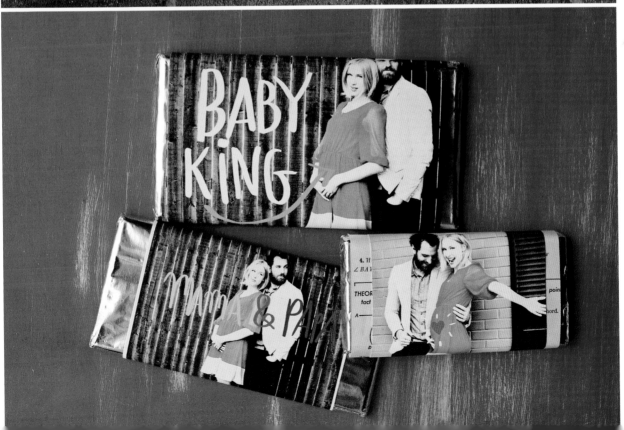

DIY BUSINESS CARDS

Have a small business? Make your own business cards to show off your unique venture. Create small personal batches of cards using any photo and as many colors as you like. There are no limits when you're creating your own!

Supplies needed:

business card–sized images, card stock, pens or paint, scissors, decorative tape

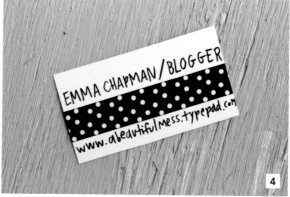

1. Use photo-editing software to create business card–size images.

2. Add text using photo-editing software or print the photos on card stock and write on them with pens or paint.

3. Print the finished photos on card stock, then cut them out.

4. Add a strip of decorative tape to the back and add business details by hand.

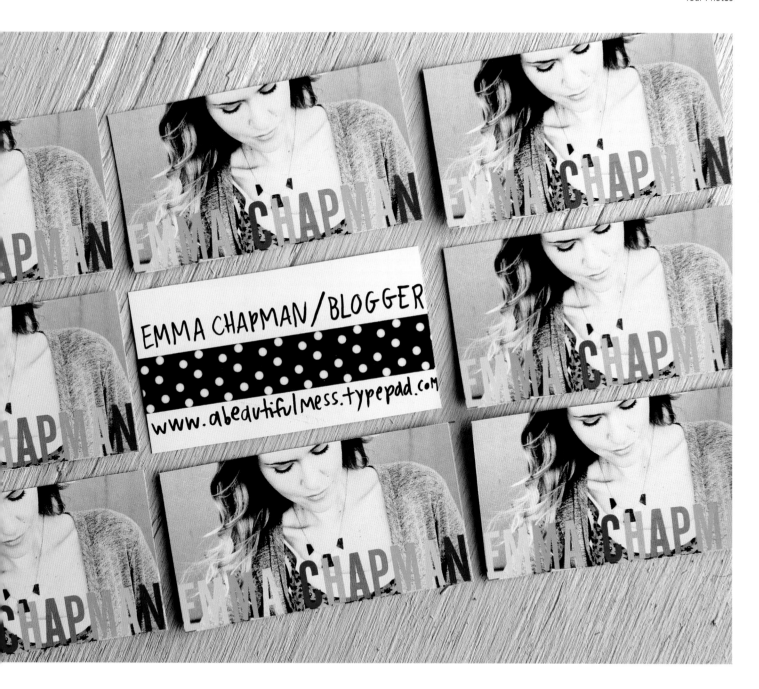

EMMA CHAPMAN / BLOGGER

www.abeautifulmess.typepad.com

GRID PHOTO WALL DISPLAY

This is an inexpensive and creative way to show off special photos and memories for anyone visiting your home. For the display shown, we used Instagram photos taken with our iPhones, which are square. If you like this look you can do the same or use regular photos and crop them into squares. Another option is to use instant photos, such as Instax or Polaroids.

Supplies needed:

printed photos, masking tape (you may need a more heavy-duty tape if your wall is brick or has extreme texture)

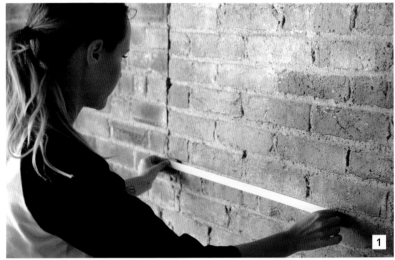

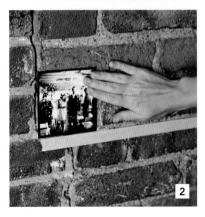

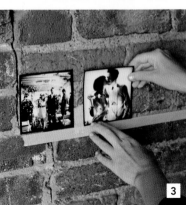

1. Use tape to create a level guide for your photos. You can do this by sight; add tape to the wall and stand back to see if it's level. Or, if you want a perfectly level design, we recommend using measuring tape or a level.

2. Use tape to stick your first photo along this line.

3. Use another piece of tape to measure the space between each photo.

4. Continue adding photos until you have filled the desired wall space.

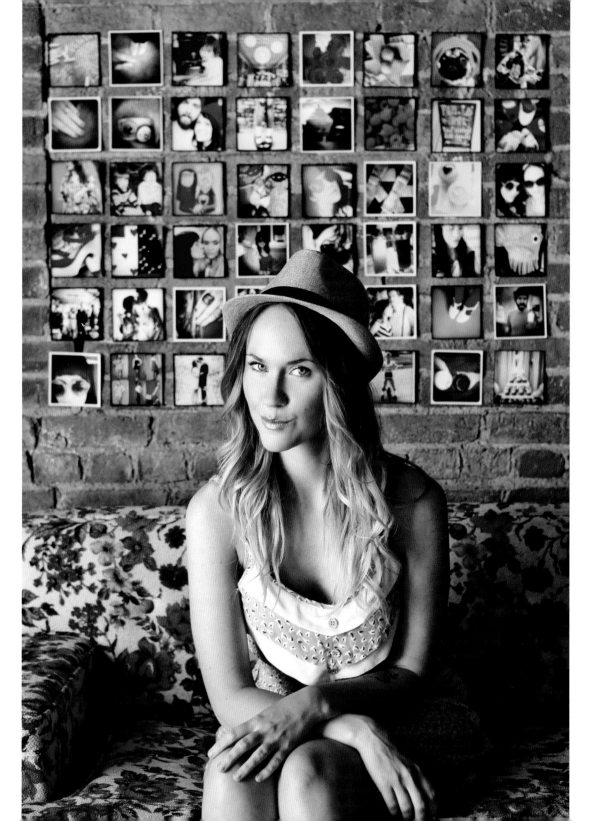

PHOTO COASTER SET

This coaster project makes a cute house-warming gift! Use your favorite family photos to personalize your coaster set, essentially creating a useful mini family album.

Supplies needed:

cork coasters (buy some or create your own from corkboard), piece of plain paper, printouts or photocopies of photos, scissors, clear contact paper, glue

1. Use a coaster as a guide to create a pattern from the plain piece of paper.

2. Lay the pattern on your photos and trace around it. Cut out your photos.

3. Use the guide again to cut out circles from the clear contact paper.

4. Glue the photos onto the coasters, then cover with the contact paper circles.

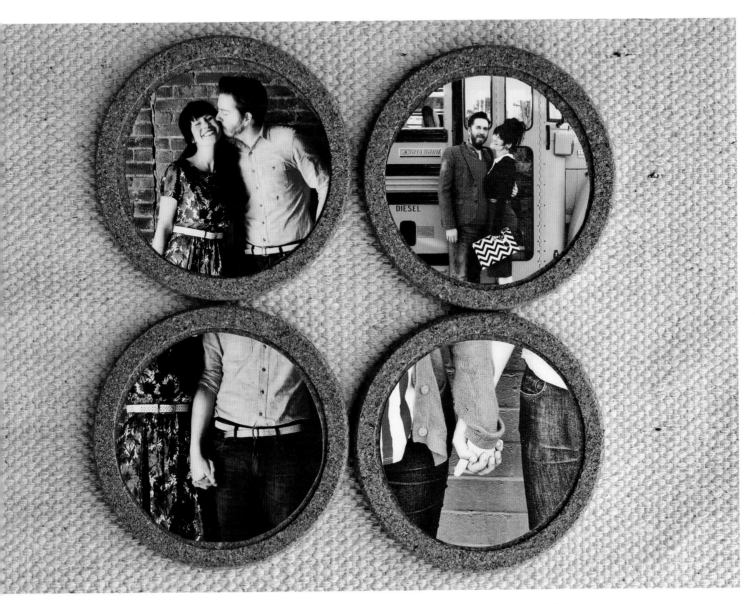

⌐ *waterproof!*

MAKE YOUR OWN SILHOUETTE

Create a silhouette of a friend's child or a cute couple and then use it to decorate a photo album or other gift for them. You can also create silhouettes from pets or special objects. Choose items that have strong, recognizable shapes.

Supplies needed:

printed photo of a profile, pen, paper for final silhouette, scissors

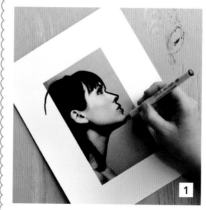

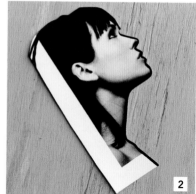

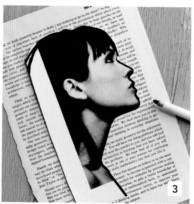

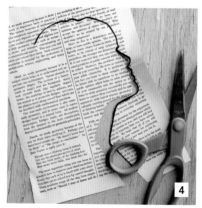

1. Use a pen to outline the profile on the photo. This will help you simplify the silhouette, removing stray hairs or other distracting features.

2. Cut out the photo, following your outline.

3. Trace your new silhouette onto the final paper.

4. Cut around the edge and display the image as you like.

CUSTOM SMARTPHONE CASE

Why not create your own personalized smartphone case? You could even use a photo you took with your cell phone—how meta is that?!

Supplies needed:

clear phone case (we got ours on eBay), printout or photocopy of photo, scissors, pen or marker (optional)

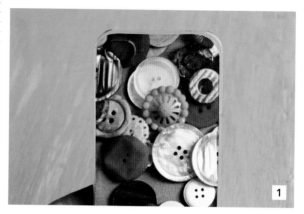

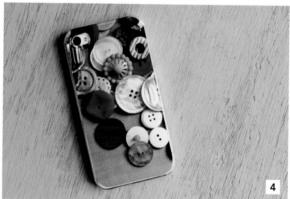

1. Cut the photo or printout to fit inside your phone case.

2. If your phone has buttons or a camera, cut out spaces for these features.

3. Decorate with pen or markers if desired.

4. Insert your phone.

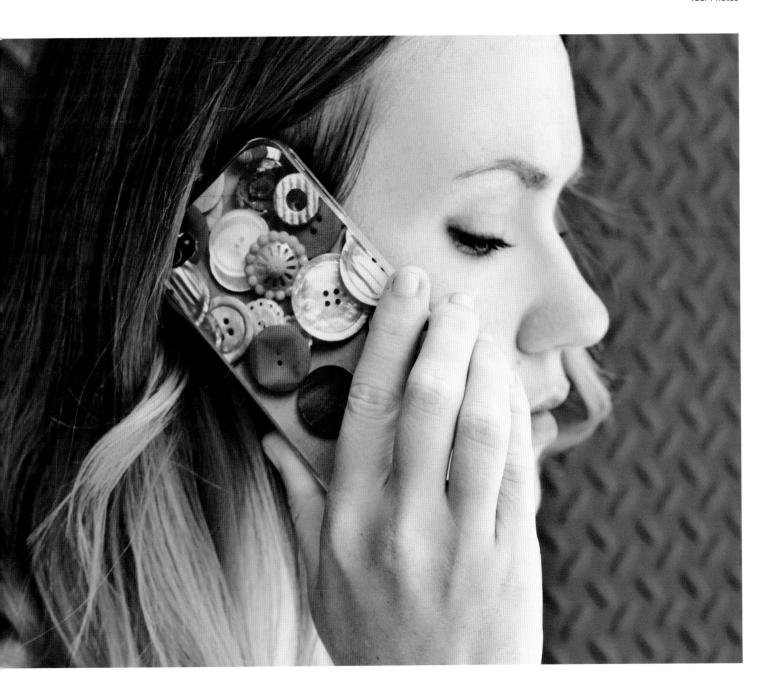

CUPCAKE TOPPERS

ometimes you want to do something a little different to celebrate a special milestone. Why not use photos to create cupcake or cake toppers that show off your accomplishments? We used photos of our very first dress line to create toppers in celebration of our fashion line's anniversary.

Supplies needed:

printouts or photocopies of photos, scissors, toothpicks, tape

1. Choose your photos. We used photos from our first dress collection. Other ideas include school photos through the years for a graduation party, or images of a couple's childhood for a bridal shower.

2. Cut out your images.

3. Tape toothpicks to the backs of the images.

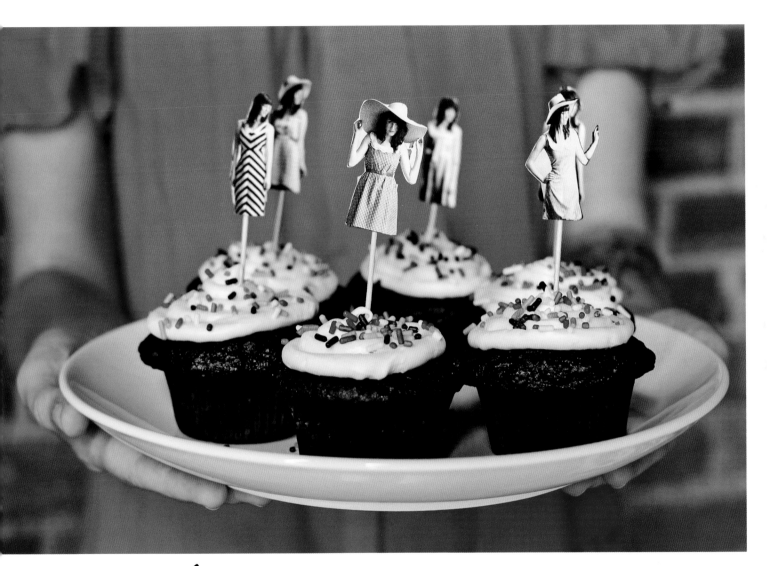

⌐delicious and pretty!

PAPER PLANE PHOTO WREATH

Wreaths can be customized to fit anyone's style. Use yarn or fabrics in colors that show off your home's personality and color palette.

Supplies needed:

foam wreath base, yarn, notebook or plain paper, photocopies or printouts of photos, scissors, glue

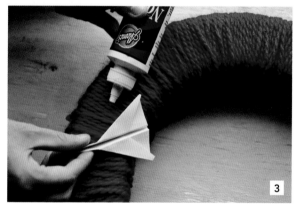

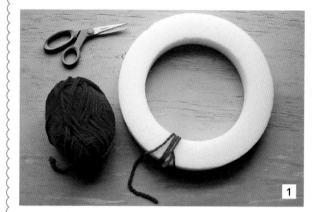

1. Wrap the entire foam base in yarn.

2. Cut out your photos and make paper planes from them.

3. Glue the planes to the wreath.

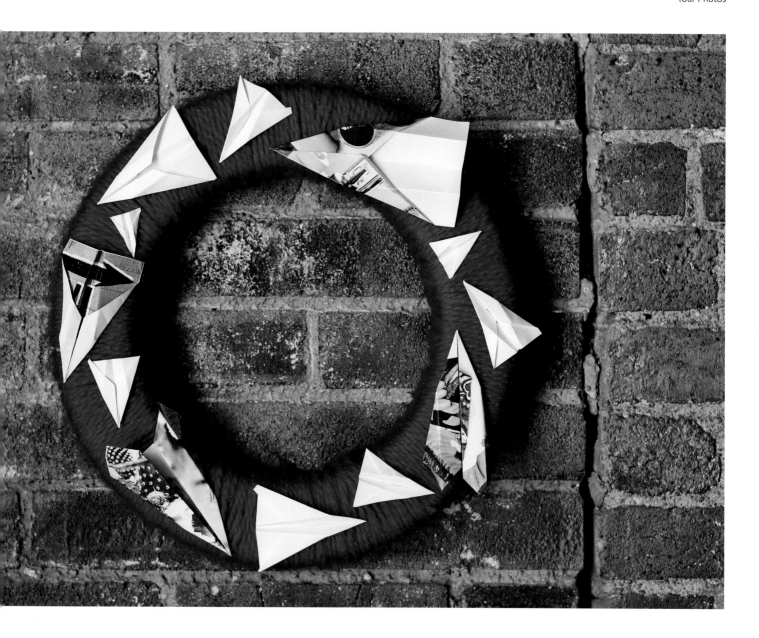

PERSONALIZED GIFT TAGS

Personalize your gifts by creating your own gift tags. Use a photo of the gift recipient or images of his or her favorite items or colors. Have fun dressing up your next present!

Supplies needed:

photos, scissors, pen, hole punch, ribbon, wrapped gift

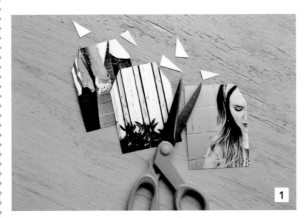

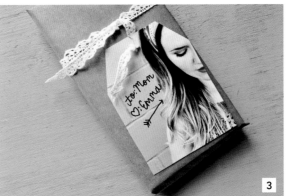

1. Cut out photos into gift tag sizes.

2. Add a message to your gift tag.

3. Punch a hole in the top of the tag, then use ribbon to secure the tag to your gift.

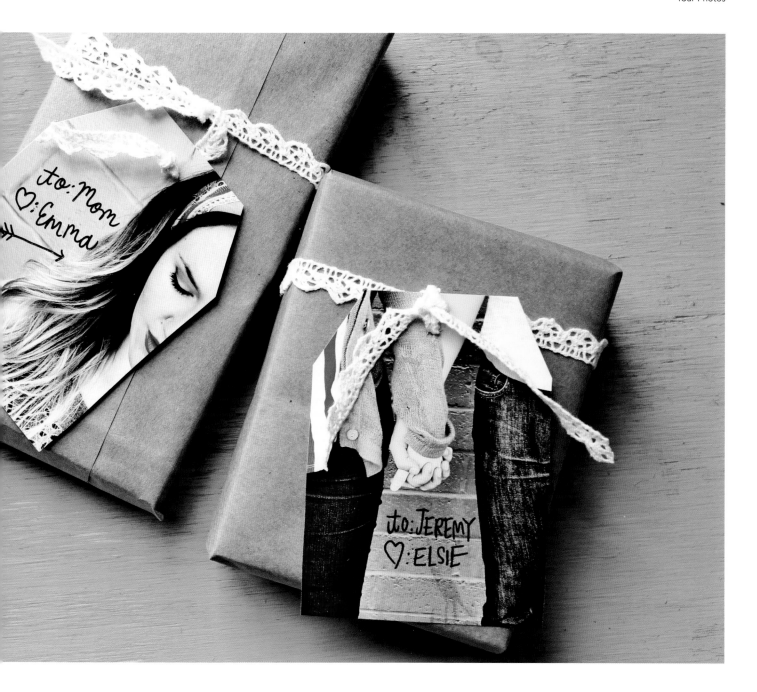

PERSONALIZED HOLIDAY ORNAMENTS

Creating your own ornaments can become a special tradition as you add new photo ornaments every year. These are also a fun gift idea for young families who are just starting their own holiday ornament collections.

Supplies needed:

printouts or photocopies of photos, scissors, clear holiday ornaments, thin pen, sequins

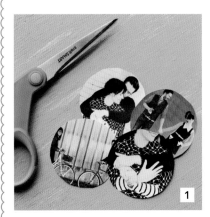

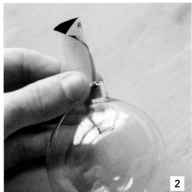

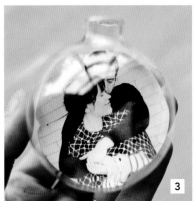

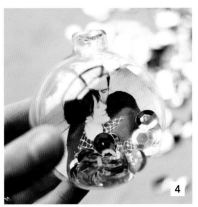

1. Cut your photos into circles. You can measure using the ornaments' diameter as a guide.

2. Roll up the image and insert it into the ornament.

3. Use a thin pen to help unroll the image.

4. Insert sequins into the ornament.

5. Replace the ornament's cap and display.

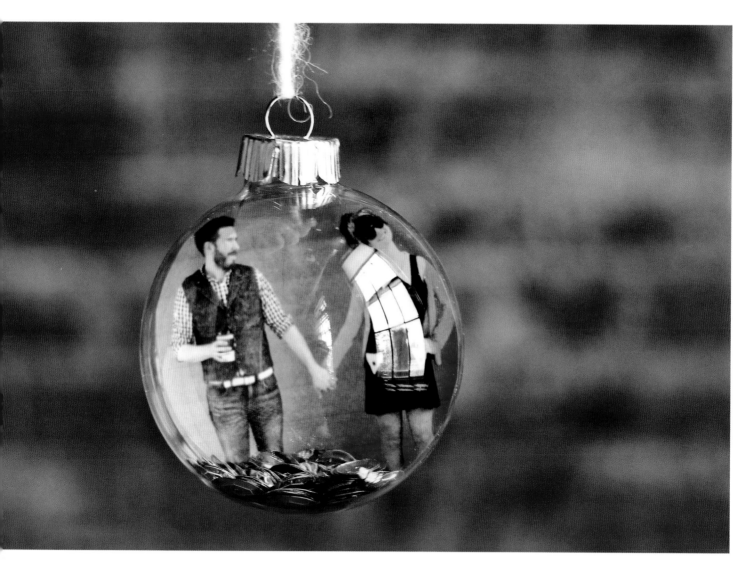

← cute and customized
holiday décor!

CLASSIC PHOTO GIFT WRAP

Use photos to create your own gift wrap! This is super easy to do for small boxes or packages. For larger gifts, try creating a collage of images or having a photo enlarged at the copy shop.

Supplies needed:

printouts or photocopies of pictures, scissors, tape, boxed gift, ribbon

1. Cut photocopies to fit your gift box.

2. Tape gift wrap securely to box.

3. Add ribbon to decorate.

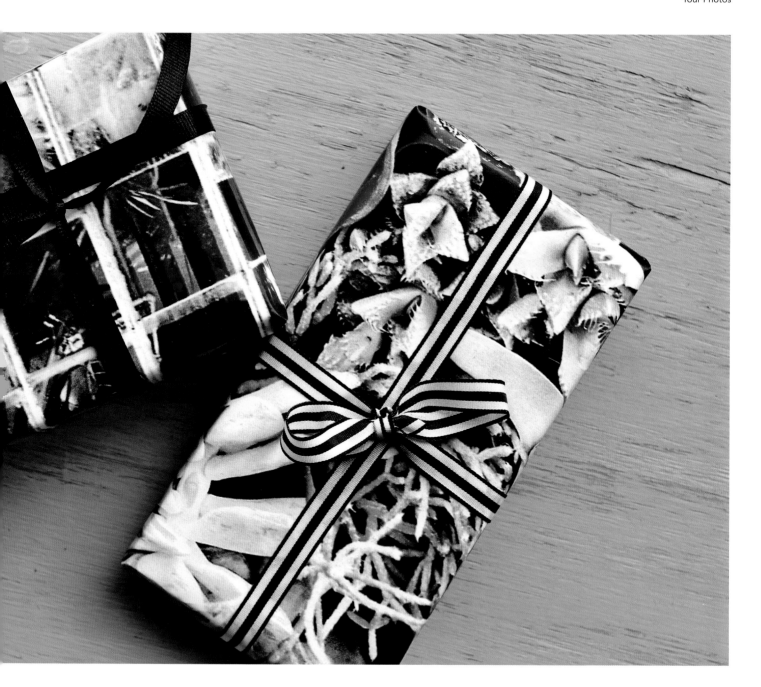

CANVAS PHOTO TRANSFERS

Photos transferred onto canvas have a slightly more rustic look than commercially printed pictures, giving them more charm. We love how black-and-white photos look with this technique. Colored photos work, too, but the final colors will be slightly less saturated than the original. Be sure to use the materials called for in this tutorial, as not every paper or gel medium will work.

Supplies needed:

paintbrush, stretched canvas, gloss gel medium (we like Liquidex and Golden brands), printout of the photo (your image will be printed in reverse, so avoid images with words), spray bottle with water

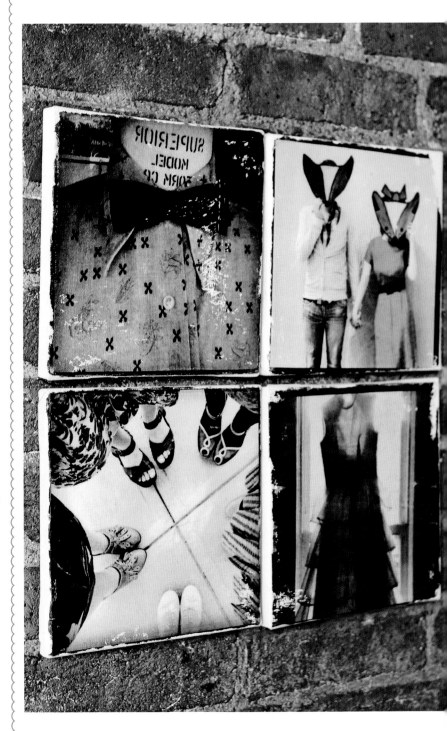

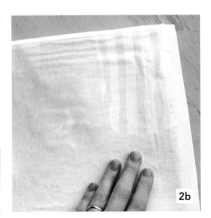

1. Use a paintbrush to cover your canvas with a heavy coat of gel medium.

2. Press the photocopy, image side down, onto the gel medium. Let dry for several hours or overnight.

3. Once dry, use a spray bottle to lightly wet the surface of the photocopy.

4. Use your fingers or an old toothbrush to gently rub the paper off, revealing your image. This takes patience and will be messy. Some small pieces of the image will likely rub off, and that's okay!

5. Once all of the paper is removed, seal your image by painting on a thin coat of the gloss gel medium. Let dry overnight.

FAMILY PORTRAIT PILLOWS

Create pillows for your couch, bedroom, or children's bedroom using images of family members or special events.

Supplies needed:

fabric photo transfer paper, scissors, fabric for pillows, measuring tape, iron (if needed), stuffing, needle, thread

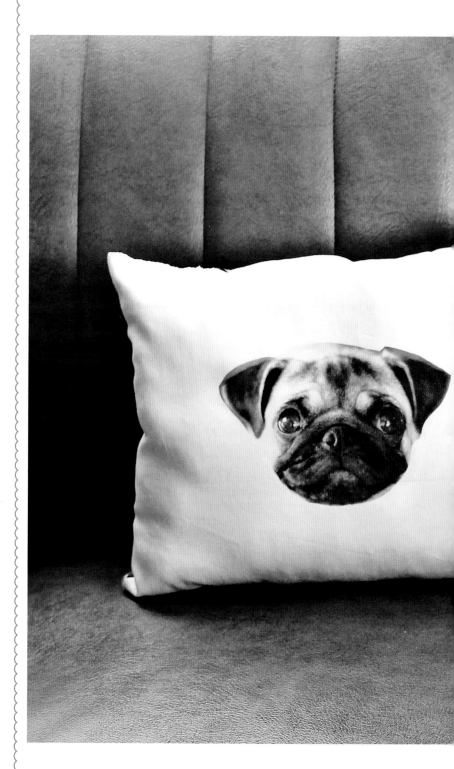

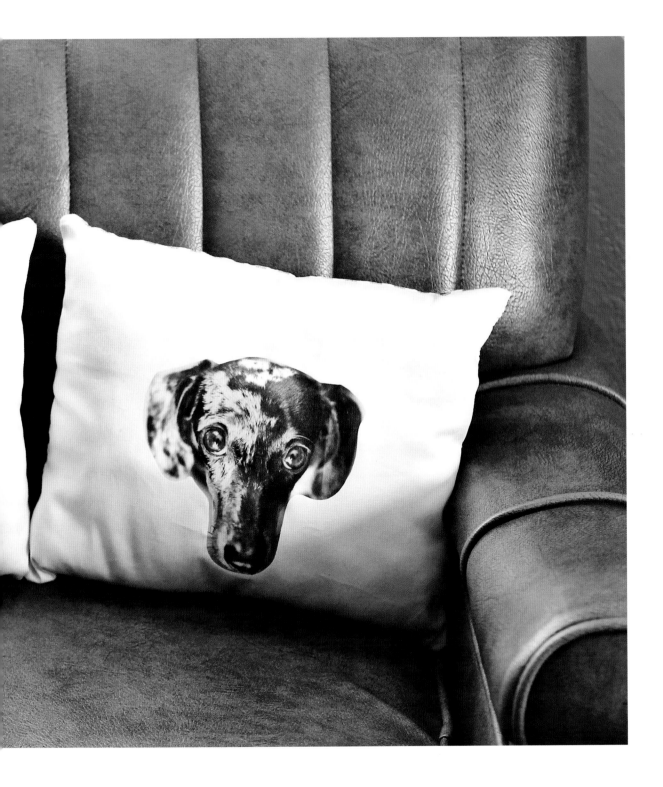

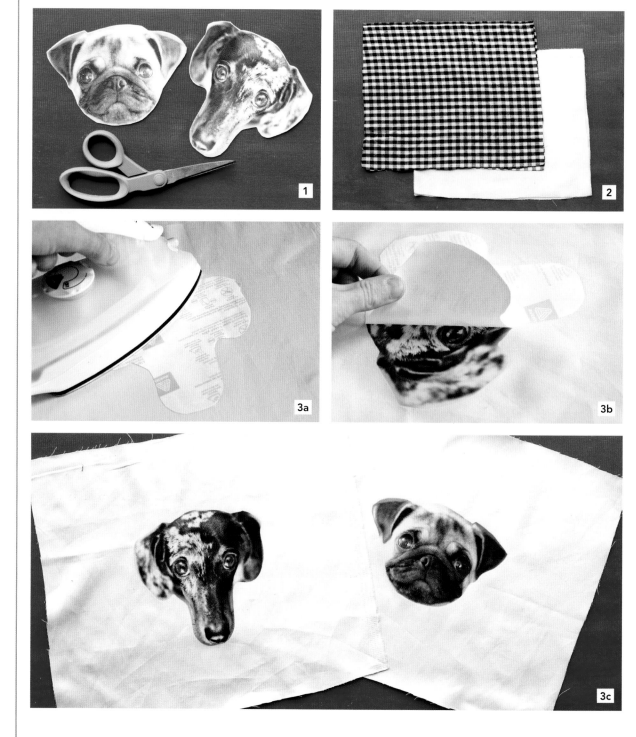

1. Print your images onto fabric photo transfer paper and cut out.

2. Cut out the fabric for the pillow. We used two different fabrics, a plain cotton for the front and a patterned fabric for the back. Ours were 9 by 11 inches; this included a 1-inch seam allowance, making our final pillows 8 by 10 inches. You can make your pillows any size you like.

3. Transfer your photos to the fabric for the front of the pillow. Follow the instructions on the transfer paper package; ours required that we iron the images onto the fabric.

4. Lay out your pillow fabrics so the fronts are facing in toward each other and sew a seam around the perimeter, leaving a 2-to-3-inch gap on one side.

5. Flip the pillow right side out and fill with stuffing.

6. Stitch up the remaining gap.

INSTAGRAM VOTIVE CANDLES

Highlight special photos in your home with this easy votive candle project. We used printed Instagram photos for this set, but you can use any size photo you like by trimming it to fit your container.

Supplies needed:

photos, scissors, Mod Podge, paintbrush, glass jars, thin fabric or paper, votive candles

1. Cut out photos to fit the size of your jars. Use Mod Podge to adhere and seal your photos to the front of the jars. Let dry.

2. Cut out thin fabric or paper to fit the exposed surface of the jar. Use Mod Podge to adhere the fabric to the jar. Let dry.

3. Add candles to the jars and display!

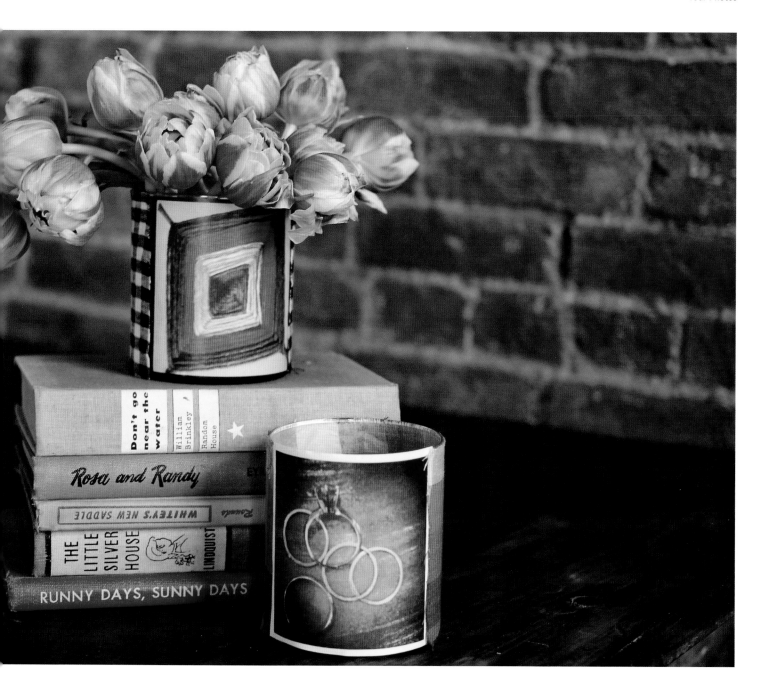

ORGANIZATION HELPERS

Are you a visual person? We are (can you tell?!). We love using images to organize our lives. There are endless ways to do this, but here are three ideas to get you started.

TEA CONTAINERS

Elsie is a tea fanatic! After trying a new tea she snaps a quick photo. She uses these photos to "label" each of her tea containers.

CALENDAR REMINDERS

Mark events in your life with small photos tucked into your planner. Print photos of each family member to label their birthdays, or use photos of past events to label upcoming events, such as a wedding photo for your anniversary. These photos will serve as quick reminders about important dates.

STORAGE BOX LABELS

We all store things in boxes, but without some kind of label, you have to open each box to find what you are looking for. A fun solution is to create labels using Instax photos of the contents of each box. You can even embellish them with fabric scraps if you like. You'll have an instant system for quickly finding whatever you want. Hooray!

organize with photos

Imagine how easy it will be to keep track of your favorite teas with photo labels.

Left: We store our hats in recycled shoe boxes but can never remember which hat is in which box. By adding a photo of the hat to each box and dressing up the boxes with fabric scraps, we have an instant (and pretty) storage solution!

Above: Elsie used a photo to note her and Jeremy's one-year wedding anniversary.

HOMEMADE GUEST SOAPS

Did you know you can make your own soap bars with photos displayed inside? Custom guest soaps are fun to use in your own home or give as gifts to friends. It's super easy; here's how to make your own.

Supplies needed:

printouts or photocopies of photos, scissors, empty cardboard carton (such as a small milk carton), glycerin soap, essential oils (optional), knife

1. Cut photocopies to fit into your carton, using the carton as a guide.

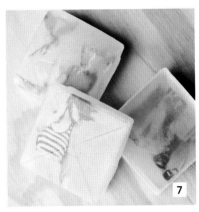

2. Melt the glycerin soap according to your brand's directions (we used the microwave). Add essential oils if you choose.

3. Pour the melted soap into the carton; use enough for one bar of soap. (You can choose how thick to make each bar.)

4. Insert your image into the container, face up. Use a spoon to push it toward the center of the melted soap.

5. Allow the soap to set in the freezer for 1 to 2 hours before adding more layers (bars of soap) into the same container. Repeat steps 3 through 5 for each layer/bar.

6. Once all the bars of soap are set, tear off the cardboard carton.

7. Use a knife to separate each bar of soap.

VINTAGE WALLPAPER SCRAPBOOK

Scrapbooks are a creative and inexpensive way to create custom albums for your photos using any materials you have on hand. For this one, we used vintage wallpapers. If you don't have vintage wallpapers, you can use any found papers.

Supplies needed:

photos, vintage wallpaper, scissors, adhesive, hole punch, ribbon, paint pens, letter stickers and other embellishments

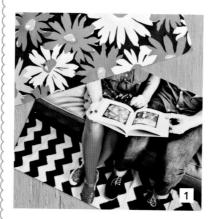

1. Lay your photos on the wallpaper and trace around your photos. Cut the wallpaper to fit your photos.

2. Use adhesive to stick the wallpaper and photos together, back to back. Repeat for all photos.

3. Punch a hole in each page.

4. String ribbon through the holes and tie for a binding.

5. Use paint pens or letter stickers to add written words to your scrapbook.

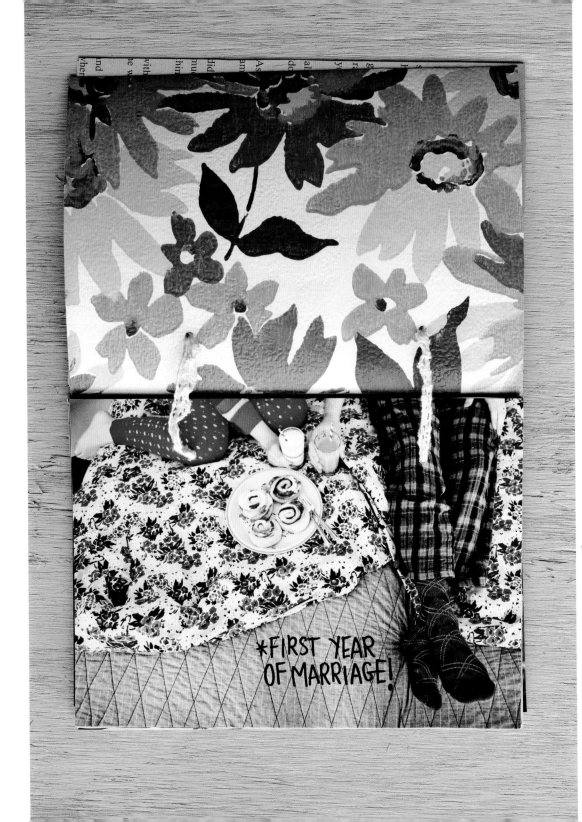

*FIRST YEAR OF MARRIAGE!

celebrate memories

GEOMETRIC MOBILE

H ere is a modern version of the classic mobile project, personalized with your photos and favorite colored papers. These can be a fun addition to a children's playroom or guest bedroom.

Supplies needed:

photos, pretty papers, scissors, yarn, decorative tape, yarn, embroidery hoop

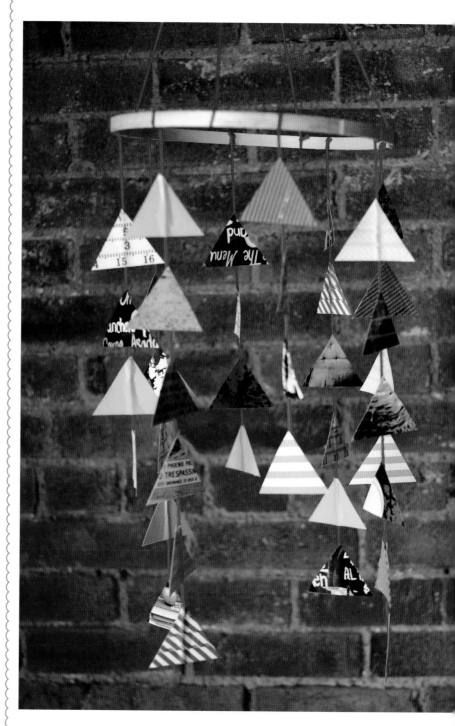

1. Cut photos and papers into uniform geometric shapes (we used triangles). We cut 48 triangles, but you can use more or less depending on how full you want your mobile to look.

2. Cut 8 long strands of yarn. These are the body of your mobile, so cut them as long as you want your mobile to be. Ours were about 15 inches long.

3. Tape the shapes to the strands of yarn, as shown, and trim off the excess tape.

4. Knot the yarn strands to the hoop.

5. Now cut four long strands of yarn; these are what the mobile will hang from. Ours were about 2 feet each. Tie the strand to the mobile, evenly spacing them. Join the four strands at the top and make a knot.

MEMORY JOURNAL

Create a memory journal using photos from your life. This easy project is a great way to personalize your own journal, or you can create one to give to a friend.

Supplies needed:

photos, adhesive, paper journal, scissors, decorative tape

1. Adhere photos to your journal cover.

2. Trim the edges.

3. Add decorative tape to the binding to secure the photo edges in place.

PHOTO FABRIC DRAWSTRING SKIRT

Getting your photos printed on fabric opens up so many project possibilities! You can create personalized curtains, bedsheets, an apron, or even a dress. Here we created a super simple drawstring skirt from a cloudy-day photo.

Supplies needed:

photo fabric (we printed ours online at spoonflower.com), measuring tape, scissors, sewing machine, needle and thread, small rope for drawstring

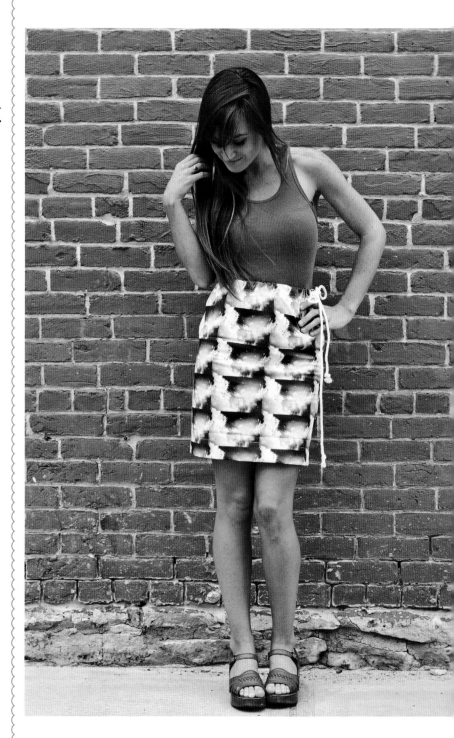

1. Cut the fabric into a rectangle for the skirt. Use a skirt you own and love as a template or create your own with the following steps:

 - Measure around your hips and add 4 inches (this is the width).
 - Measure from your waist down to where you want the skirt to fall, then add 3 inches (this is the length).
 - If you want a fuller skirt, add more width to the bottom and cut an angled line from the waist to the bottom of the skirt.

2. Find the top of your skirt (it should be one of the long sides). You're going to prep the top to create the sleeve for the drawstring. Make a 3-inch-long hem down each of the sides, starting at the top, as shown.

3. Fold the hemmed portion in half and stitch along the top edge of the skirt, creating a sleeve for the drawstring.

4. Fold the fabric in half to "create" the skirt, with the wrong side of the fabric facing out. Make a hem to close the open side, starting directly below your drawstring hole and continuing to the bottom of the skirt.

5. Hem the bottom of your skirt.

6. Feed your drawstring through the sleeve and try on your new skirt!

REFINISHED PHOTO CHAIR

n need of a room makeover? Here's an easy and inexpensive way to spice up an old piece of wood or plastic furniture. By using your own photos, you can choose a color palette that's perfect for your specific room. Keep in mind that this treatment is permanent, so avoid using a priceless antique piece!

Supplies needed:

old chair or other furniture item, sandpaper, paintbrush, Mod Podge, printouts or photocopies of photos, scissors, brush-on gloss glaze

1. Lightly sand the surface of your chair. This will help the adhesive stick to it better.

2. Begin painting on a thick layer of Mod Podge.

3. Add your photocopies to the area coated with Mod Podge. Smooth them onto the surface, removing any wrinkles. Continue until you have covered the entire surface, then allow to dry.

4. Trim excess photocopies around the edge of the chair.

5. Lightly sand the edges to help keep the photos from peeling.

6. Seal the entire surface with brush-on gloss glaze.

DIY TRAVEL SUITCASE

Planning a cross-country road trip this year? Here's a fun way to personalize your luggage and show off your travel photos all in one project! You can add travel photos to your suitcase over the years, making it a functional photo album of sorts. Or you can use photos from a favorite trip, such as a honeymoon or family reunion.

Supplies needed:

printouts or photocopies of photos, scissors, Mod Podge, paintbrush, hardcover suitcase, craft knife

1. Cut out your photos.

2. Brush a layer of Mod Podge onto part of your suitcase and begin adhering photos. Keep going until as much or as little of your suitcase is covered as you'd like.

3. Use your craft knife to cleanly trim the edges of the photos along the suitcase edge.

4. When you're finished, seal the suitcase by brushing on a thin layer of Mod Podge. Let dry thoroughly before use.

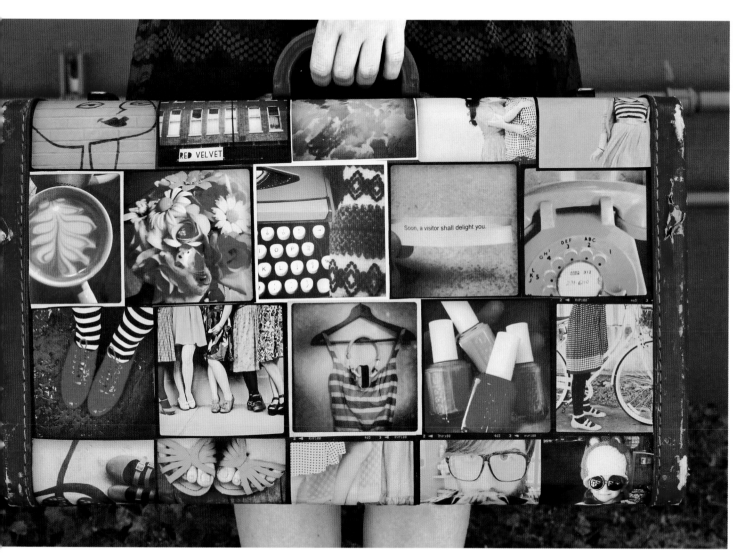

↖ travel in style!

FIVE WAYS TO ORGANIZE YOUR PHOTOS FOR FUTURE PROJECTS

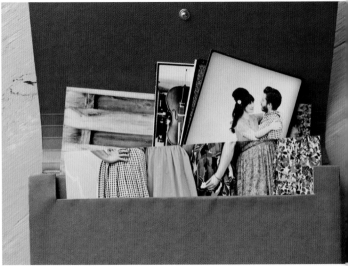

You can easily find old photos when you need them if you've filed them away.

Along with using your photos to make projects, it's also a good idea to organize your photos, whether to use them in future projects or to have them in your home to share with friends and family. Saving these images ensures that even if we tire of a past project, we won't lose the images used to create it. Here are four ideas for organizing your photos.

✳ **FILE FOLDERS.** There's nothing wrong with a good old-fashioned file folder! These folders are self-contained and have dividers to further organize your pictures. They are readily available at any office supply store and inexpensive—bonus!

❋ **PHOTO BOOKS.** Create your own photo book using editing software, either printing and binding it yourself or having it done commercially. There are also a few websites that will help you create one and then ship it to you. The one shown here was made on blurb.com.

❋ **PHOTO ALBUMS.** You can still get crafty with traditional photo albums, or leave them plain and classic. For the ones shown here, we purchased plain black photo albums and added the year to the spine with number stickers.

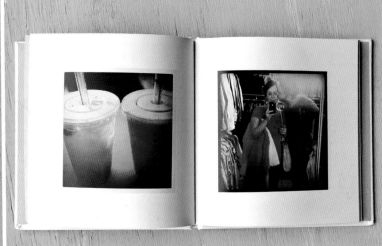

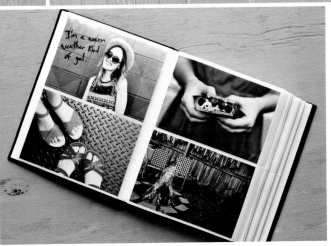

Above: Elsie created this photo book using Instagram photos from her first year of marriage.

Left: These albums provide a ready-made place to store photos for the next few years.

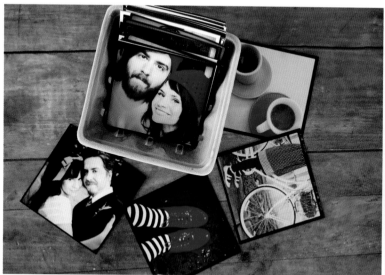
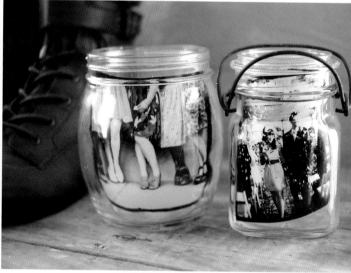

We love discovering new little nooks to house our printed photos!

✳ **CONTAINERS.** Small decorative boxes and jars can be found at thrift stores and vintage shops and make great photo holders. (Bonus: they are often the perfect size for square Instagram photos.) You can then leave these containers out on coffee tables or kitchen counters for guests to enjoy. Take a peek around your house and see if you already have the perfect containers for your printed photo collection.

✳ **ONLINE.** And don't forget about saving photos online. There are so many places to store digital photos, such as flickr.com. When you store them online you don't have to worry about your computer or hard drive crashing. Some sites require a small fee for this service, but knowing that your documented life and family portraits are safely stored is worth it in our opinion.

OUR GEAR: *An Inside Look*

You may be wondering what kind of equipment was used during the making of this book. You are, aren't you? We're not big believers that it takes fancy gear to make a great photo. We have owned and used all sorts of cameras over the years. And we're happy to share the cameras and lenses used for this book, as well as our personal favorites.

We own two digital SLR cameras, a Canon EOS 60D and a Canon EOS 40D. We love them both! We used to own Canon 40Ds, but when one of the 40Ds was ready to retire we upgraded to the 60D. Lots of dSLR options are available on the market, so if you're interested in getting one or updating your current model, shop around and find what's right for you.

We use a variety of lenses, depending on what we are photographing. About 80 percent of the time we use a Canon EF 35mm lens. This is a great everyday lens. If we were stranded on a deserted island and we could have only one lens with us, it would be this one. Another lens we use often is the EF-S 77mm. This is an excellent lens for arms-length self-portraits and outdoor scenery photos. We also own a Canon EF 85mm lens, which is great for close-ups, such as for food photography.

We also use our iPhones for quick candid pictures or when we've forgotten our cameras at home. There are tons of photo apps you can use to edit your iPhone shots. Our current favorites are Instagram, Picture Show, Tilt Shift, Hipstamatic Disposable, and VSCO Cam.

Elsie loves using her Wacom Bamboo Pen Tablet. She often uses it to digitally add handwriting onto photos when editing them.

We use Adobe Photoshop CS to edit most of our photos, but we also love CS's less expensive little sister: Photoshop Elements. There are many photo editing software programs out there; shop around and find what works best for you.

Some of our favorite gear (left to right): Wacom Bamboo Pen Tablet, various lenses, our Canon dSLR, our iPhones.

INDEX